The
Impressionist
Landscape

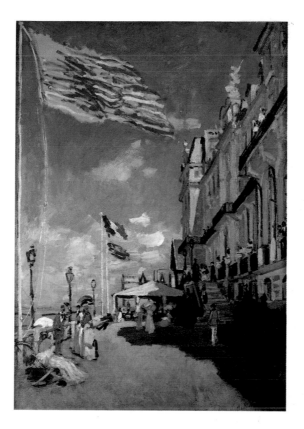

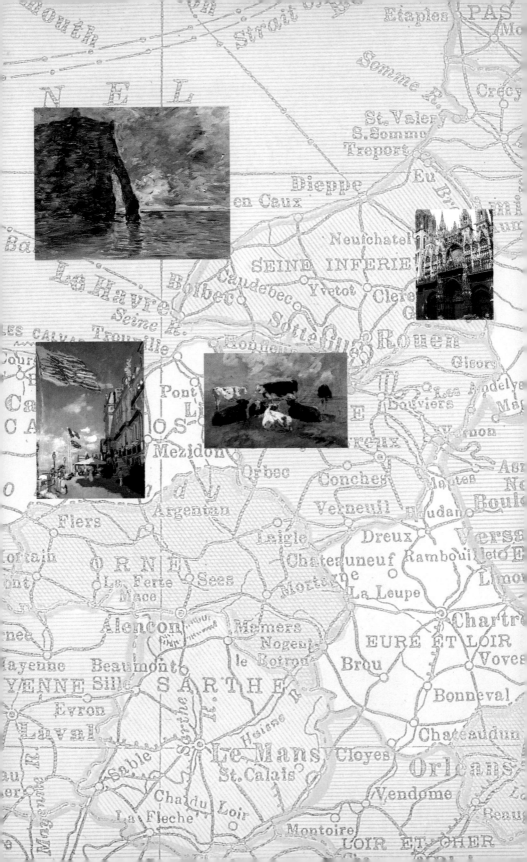

A Guide to

The Impressionist
Landscape

Day Trips from

Paris to Sites of Great

Nineteenth-Century

Paintings

PATTY LURIE

PHOTOGRAPHS BY

BERTRAND DE CHAUVIGNY

AND PATTY LURIE

A BULFINCH PRESS BOOK

LITTLE, BROWN AND COMPANY

BOSTON TORONTO LONDON

Dedicated to Josette and Claude

First Edition

Produced for Bulfinch Press by Marquand Books, Inc., 506 Second Ave., Suite 1201, Seattle, Washington 98104

Library of Congress Cataloging-in-Publication Data
Lurie, Patty, 1944–
 A guide to the Impressionist landscape : day trips from Paris to sites of great nineteenth-century paintings / Patty Lurie. —1st ed.
 p. cm.
 "A Bulfinch Press book."
 ISBN 0-8212-1796-8
 1. Landscape painting, French. 2. Landscape painting—19th century—France. 3. Impressionism (Art)—France. 4. Impressionist artists—France—Biography. 5. France—Descriptions and travel— Guide-books. I. Title.
ND1355.5.L8 1990
758' . 144 ' 094409034—dc20 90-5856

Bulfinch Press is an imprint and trademark of Little, Brown and Company (Inc.)
Published simultaneously in Canada by Little, Brown & Company (Canada) Limited

PRINTED IN SINGAPORE

Contents

Preface

Research for this book started accidentally in the summer of 1984. In May of that year I had completed a series of oil paintings inspired by the lives and paintings of the French Impressionists. Countless times I had read about and seen in color reproductions a special, unique quality of light reflected on trees, water, flowers, roads, and buildings. Wanting to experience the nuances of this different light, and to know exactly where these artists painted their most famous landscapes, in July of that year I traveled to France. I wanted to stand in their shoes, look through their eyes, and possibly find inspiration for my own work as a painter.

My original plan was to search out an exact site and then return with paint, brushes, and canvas in hand. For three days I wandered around Auvers-sur-Oise (finding van Gogh and Cézanne sites), Moret-sur-Loing (finding Sisley and Pissarro sites), and Bougival (finding Monet, Pissarro, Renoir, and Sisley sites). On the fourth day I put away my painting supplies and continued what was to be a life-changing adventure.

I became the consummate detective. Every day, with color reproductions in hand, I ventured on the train (as the Impressionists had done before me) out to the countryside in search of exact painting sites. To my delight and amazement, I found that the French are not anxious to tear down old structures to replace them with new ones. Many sites were exactly the same.

Eventually I discovered scores of locations, many more than I have been able to include in this small volume. No words can describe the experience of seeing the church painted by van Gogh in Auvers or strolling the Pontoise village paths favored by Pissarro. In Moret-sur-Loing, layers of clouds like those studied by Sisley still move quickly overhead, and in Étretat the cliffs painted by almost every Impressionist are just as majestic and awesome.

The only location that is vastly different today is the Paris suburb of Argenteuil. Walking by the banks of the Seine, however, I was struck by the fraternity of the Impressionist school. Never before had a group of artist

friends with such selflessness shared ideas, painting techniques, and, most important, outdoor painting locations.

I would like to thank the countless anonymous French people who graciously offered assistance and suggestions while I was exploring the countryside. Equally helpful were the staffs of tourist offices and local museums. Jacques and Monique Läy in Louveciennes, Jacques Dangé and Ray Beaumont-Craggs in Moret-sur-Loing, Madame Cayrol and Alain Fournigault in Pontoise, Michel Flammand and Joseph Fiorenza of S.N.C.F., and Isabel Volk of Service Photographique de la Reunion des Musées Nationaux deserve particular recognition.

Next a special thanks goes to Darra Romick, who read the manuscript while I was writing; Dottie Morey, who typed the text; Josette Tavera, former registrar at the Musée Marmottan, and Claude Grinberg, who offered places to stay, food to eat, and wine to drink while I was in France; David Tweedy, who offered moral support from the book's inception; and my loyal jewelry and painting customers, whose financial support allowed me to work on this project.

Without the expertise of Marquand Books, Inc., this book might never have come together. I am especially grateful to Suzanne Kotz for her relentless editing. Thanks also to Carol Judy Leslie at Little, Brown and Company, who encouraged me to pursue publication of this guide.

Last I thank photographer Bertrand de Chauvigny, who diligently, persistently, and without complaint satisfied our insistence for exact location photographs.

I now know without a doubt that the light in France is different from that in California: I am currently living and painting in Paris. I am also working on two more site guides—one for Paris, the other for the south of France. I would appreciate any comments or suggestions from those of you who venture out to the countryside. *Bonne chance!*

How to Use This Book

A Guide to the Impressionist Landscape leads you on a series of day trips from Paris to the sites of some of the world's most treasured paintings. Each section begins with a brief introduction to the region and to the artists who worked there. Tour itineraries and walking directions, conveniently arranged next to interpretive and informative notes, allow you to follow a route and also learn the significance and history of each locale.

The tours are all planned as outings of not more than one day, departing from and returning to Paris as a convenient central point. The tours move around the suburbs of Paris, then to the countryside and the Normandy seacoast. (They may, of course, be followed in any order, and some travelers may wish to stay elsewhere than in Paris, making other travel connections than those given here.)

Tour information begins with directions for your departure, usually on the trains of the French Railways (S.N.C.F.) from Gare Saint-Lazare. The station is easily reached on the Métro. Be sure to carry plenty of coins for the silver-colored automatic ticket machines, and don't forget to stamp your ticket before boarding. Orange ticket-stamping machines are at the entrance to the tracks. You may also travel on the Réseau Express Régional (RER), the rail system that serves the Paris suburbs. Essential information about which trains to take, the fares, and general travel times is included at the start of each tour. Fares listed are for second class, round-trip tickets, unless otherwise noted.

Before starting off on a walk to painting sites, study the maps that accompany each tour. On them are marked the locations of local tourist offices.

Visit these offices to gather additional information. Subheadings in the *Guide*—for example, "Route de Versailles to Parc de Marly"—indicate the general sections of each tour. With the maps, they will help you become quickly familiar with the landmarks and streets of each part of the tour.

The narrow column of print in each chapter contains an itinerary that carefully directs you, from your arrival at the train or bus station, through the town and on to particular painting sites. Always read the narrow column first; this information allows you to get your bearings as you proceed through the tour. The broader text column offers lively comments on the artists, their paintings, the sites, and the town as the tour unfolds. It will be helpful to review these remarks during the train ride from Paris, and then to read them again while walking.

Use the illustrations of the paintings and their present-day sites to orient yourself to the landscape that the artists saw over 100 years ago. (Illustrated paintings are highlighted in bold type in the main text.) Although some of the sites have changed greatly, an amazing number still retain the essential features of architecture and landscape that originally attracted the Impressionist artists.

Some of the paintings illustrated or mentioned in the *Guide* are in the collections of small regional museums. Whenever possible, the *Guide* directs you to them. Many other paintings are in the Musée d'Orsay and the Musée Marmottan in Paris. Consult the list, arranged by artist, at the back of the book for the museum locations of all the paintings mentioned in the tours.

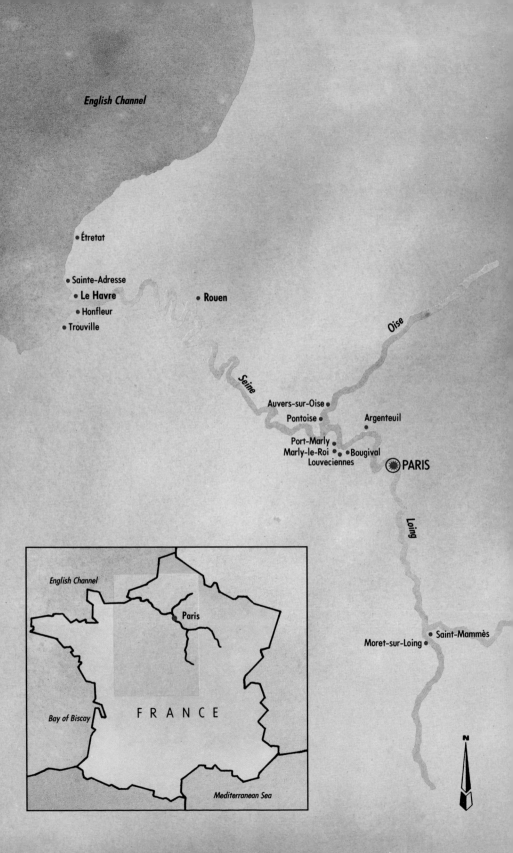

The Birth of Impressionism

Some say Impressionism was born in 1869 on the banks of the Seine near Bougival. There Claude Monet and Pierre-Auguste Renoir, working side by side, each painted three views of the famous floating cafe, La Grenouillère. With loose fragmented brushstrokes of pure unmixed color, they captured the shimmering Seine, contrasting brightly sunlit areas with color-filled shadows.

I personally would extend this nascent period to 1872, to include paintings of the country roads and village environment of Louveciennes. Here Monet and Camille Pissarro also stood together and painted the route de Versailles, capturing the effects of snow and cloudy skies on traveled roads and leafless trees.

Today it is hard to imagine the shock with which their kind of painting struck its first audience. That audience was accustomed to thinking about art in terms of the standards for subject and style endorsed by France's prestigious Academy of intellectuals and philosophers, and exemplified in the juried exhibitions of artworks shown in annual Salons.

Yet it was not as if the early Impressionists were the first painters in three centuries to interest themselves in realism and naturalism. Nor did they invent the subjects of landscape, domesticity, humble life, or intimate portraits. Rembrandt had painted those subjects; Velásquez, in 1630, once painted a quick sketch of the Medici gardens in a manner that Camille Pissarro would have found sympathetic 250 years later. But the official art of the court and later of the Academy was an art of high seriousness and lofty themes. It conformed to time-honored attitudes, didactic purposes, and widely accepted expectations about techniques of painting.

The Impressionists, who wished to avoid all "isms," called their work "the new painting." They abandoned many of the canons of earlier art as well as those of their own time to achieve a new imagery and a new experience of painting. Turning away from the Romantics' goal of evoking spiritual feelings with imaginary, idealized scenes, the Impressionists began to paint real landscapes seen in real time. Instead of the carefully modeled Neoclassical ideal human form, they studied the lumps and bulges of ordinary people. They turned from the solemn responsibility of depicting kings, princes, prelates, and officials in order to honor anonymous strollers, revelers, workers, and peasants in unexalted walks of life.

Monet and Renoir, for example, chose to paint scenes of gaiety and pleasurable leisure activities. They captured the mood of optimism and economic growth that preceded the Franco-Prussian War of 1870, when Parisians were looking for fun and adventure. Alfred Sisley, whose Parisian paintings of 1869–70 already showed signs of the Impressionist style, moved to Louveciennes in 1871. Then he, too, painted the reflecting Seine at Bougival and wandered the roads and paths of Louveciennes.

Rejecting the classical linear perspective and pictorial illusionism of the Renaissance, the Impressionists worked to obtain a flattened picture plane where color alone achieved spatial volume and modeling, where no shadow was ever black, no line ever straight. They left behind the smooth brushwork and delicate surface glazes of the Old Masters to explore the texture and plasticity of paint itself. They tried to translate their visual impressions into pictorial ones by the sheer energy that drove their brushes.

Most significant, the Impressionist painters determined to catch time — not to arrest an immortal, unchanging kind of time, but to snatch at the

coattails of fleeting moments—a sunset, a picnic, a momentary condition of light caused by a rising mist. To do this, they painted not in their studios but outdoors. And they usually painted rapidly, finishing works on relatively small canvases in an afternoon, a few days, a week—unlike artists before them, who had often expended long, painstaking months in the studio executing vast canvases full of complex allegory, historical or literary allusion, and technical virtuosity. By contrast, water scenes and country roads became distinctive Impressionist motifs.

During these years, a mutual exchange of ideas and technical knowledge occurred among these early Impressionists, who all had studied Jean-Baptiste Corot, Charles-François Daubigny, and Eugène Delacroix. As they painted and fueled each others' ideas, a distinct new movement emerged. What had started in the studios and cafes in Paris culminated on the banks of the Seine near Bougival and in the countryside of Louveciennes.

As Charles Moffett reminds us (*The New Painting: Impressionism 1874–1886*, San Francisco, 1986), all this was first received by critics as the work of lunatics; it was once deemed so awful that pregnant women were warned to avoid the risk of seeing it. But the Impressionist painters were not deterred. These vital new masters had the strength and courage of their convictions, and their undeniably innovative painting style existed by 1872. The first of eight Impressionist exhibitions was held in 1874, when the term "Impressionism" was introduced, although the exhibitors did not endorse the expression. The show marked the public's first awareness of this new artistic vision. During the next decade, these artists would produce their mature work as Impressionists.

ITINERARY

TOUR TIME: about half a day

MARLY-LE-ROI TOURIST OFFICE
Place du Général-de-Gaulle
Tel: 39-58-73-00
There is no tourist office in
Louveciennes.

MUSÉE PROMENADE
(Parc de Marly)
Hours: Wed.–Sun., 2–6 p.m.;
closed holidays

FARES
Paris to Louveciennes,
one way: 10 Fr
Marly to Paris, one way: 10 Fr

To go to Louveciennes, take one of
the frequent trains from the Gare
Saint-Lazare, platforms 1–4. Buy a
one-way ticket (you will return
from Marly). The trip takes about
25 minutes.

LOUVECIENNES AND MARLY-LE-ROI TOUR

Louveciennes and the neighboring town of Marly-le-Roi are both quiet, tree-filled suburbs of Paris. Many commuters make the short trip daily into the capital. As you walk through these towns, notice the many beautiful, fashionable, old and new French homes. The flickering light of the area is woven into many works of Monet, Pissarro, Renoir, and Sisley.

In addition to many painting sites, this tour offers something very special. Between Louveciennes and Marly is the Musée Promenade, on the grounds of Louis XIV's country residence, Château de Marly (now destroyed). The museum displays a permanent photographic exhibition, with a guide book, *De Renoir à Vuillard*, which chronicles the Impressionists. The photographs of the area by Jacques and Monique Läy (two local residents) are fascinating.

Another intriguing museum display is a working model of the Machine de Marly, the ingenious and widely renowned hydraulic device that brought water from the Seine to the château, and on to the distant Palais de Versailles.

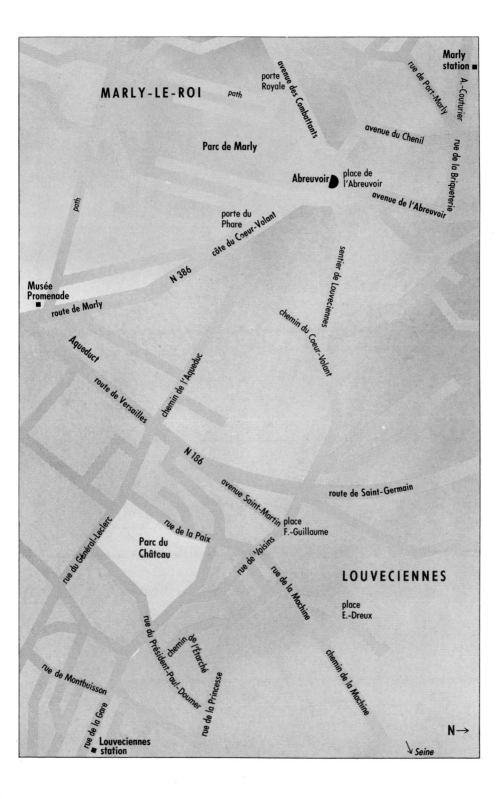

MARLY-LE-ROI · path

Marly station ■

rue de Port-Marly
A.-Couturier

porte Royale
avenue des Combattants

avenue du Chenil

rue de la Briqueterie

Parc de Marly

Abreuvoir · place de l'Abreuvoir

avenue de l'Abreuvoir

path

porte du Phare
côte du Coeur-Volant

N 386

sentier de Louveciennes

chemin du Coeur-Volant

Musée Promenade ■
route de Marly

Aqueduct

route de Versailles

chemin de l'Aqueduc

N 186

avenue Saint-Martin

route de Saint-Germain

rue du Général-Leclerc

rue de la Paix

place F.-Guillaume

Parc du Château

rue de Voisins

rue de la Machine

LOUVECIENNES

place E.-Dreux

rue du Président-Paul-Doumer

chemin de l'Étarché

chemin de la Machine

rue de Montbuisson

rue de la Gare

rue de la Princesse

Louveciennes station ■

N→

↘ Seine

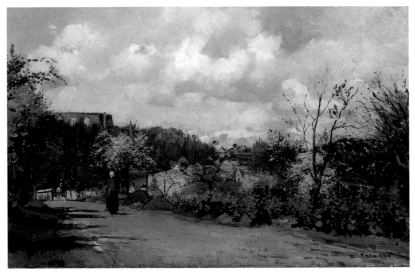

Pissarro, *View from Louveciennes*, c. 1870

Rue de la Gare to Chemin de l'Étarché

When you arrive at the small station in Louveciennes, exit the main door and immediately cross the street, rue de la Gare. Turn right (northwest) to view your first site.

As you leave the Louveciennes station, you can find the site of an early Pissarro work, **View from Louveciennes** (c. 1870), by spotting the aqueduct, barely visible on the horizon and slightly to the left.

In 1869–70 Pissarro had left Paris and was already residing in this area. He painted a few

water scenes, but early on he chose to concentrate his efforts on rural landscapes. At this point Pissarro still was influenced by the palette of Corot. Less colorful than Monet's and Renoir's works of the same time, Pissarro's painting does show a beginning Impressionist style. A few fragmented brushstrokes imply light, and the scene has an impermanent, airy quality.

Renoir also painted this view of Louveciennes with the aqueduct in the background in *A Road in Louveciennes* (c. 1870).

Walk to the chemin de l'Étarché, a tiny village road that has barely changed in more than a century. You are now facing the location of Sisley's **Snow at Louveciennes** (1878), one of several mature Impressionist landscapes he painted in or near this pathway between 1874 and 1878. Painted under a dull winter sky, this work portrays the radical effect of season and atmosphere on the nature of light. Sisley added bits of reflected color to emphasize the snow's iridescent, illuminating quality.

Walk in the direction of the aqueduct on rue de la Gare. Turn right at rue du Président-Paul-Doumer. Follow this road under the train tracks and immediately turn left up a short, very steep, paved but unmarked road, chemin de l'Étarché. At the top, at the first fork, keep left and walk about halfway down the path.

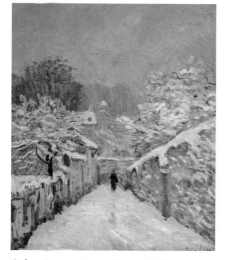
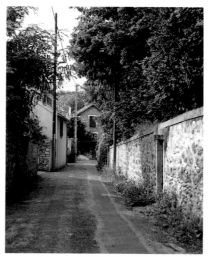

Sisley, *Snow at Louveciennes*, 1878

Place Ernest-Dreux

Continue up the pathway to the main street, rue de la Princesse, and turn left. Turn right when the street meets rue de la Machine. Follow the sign on the left to place Ernest-Dreux.

Ahead, at place Ernest-Dreux, you will see the site of Sisley's **The Road of the Machine at Louveciennes** (1873). This road leads to the former location of the Machine de Marly, the mechanism that pumped water to the fountains and pools of the Château de Marly and the Palais de Versailles. From the road beyond (inaccessible today), Sisley painted *Louveciennes, Hilltops at Marly* (c. 1873).

Sisley's painting done on rue de la Machine is a worthy example of his work prior to 1874, when he was discovering himself as an Impressionist painter. The golden browns and greens bespeak his Barbizon days, but the natural play of light in the trees and the unobtrusive figures walking along the path show his concern for a more human and temporal kind of painting than was preferred by his Barbizon predecessors. With expertly applied brushstrokes, he captured the exact time of day and season. By emphasizing perspective, Sisley forces us to look far beyond the scope of the painting. Throughout his career he retained a concern for light and how it affected solid structures, figures, and sky.

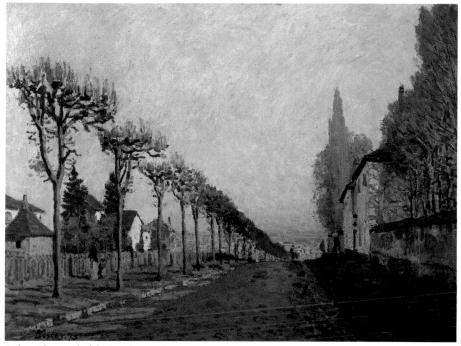

Sisley, *The Road of the Machine at Louveciennes*, 1873

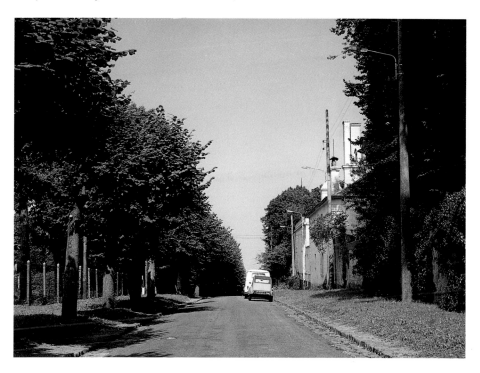

Rue de Voisins to Route de Versailles

Backtrack on rue de la Machine to rue de Voisins. Turn right. (On the corner at rue de Voisins, notice the ancient Pharmacie de Madame du Barry, built in 1783. There the favorite mistress of Louis XV preserved the herbs she used to make medicinal teas and balms.)

Walk a few moments on rue de Voisins to avenue Saint-Martin, turn left, and pass over the railroad track. A few steps farther on (near the bench), turn around to see the site of Pissarro's *Entrance to the Village of Voisins*.

Renoir's and Monet's interaction at Bougival in the summer of 1869 has been readily acknowledged as a critical moment in the development of the Impressionist style. Just as significant, perhaps, was the relationship between Monet and Pissarro at Louveciennes later that year. Monet had already learned to capture the fleeting moment on canvas, and under his influence, Pissarro now began to alter his landscapes to emphasize the temporal nature of a scene rather than its structure.

Both Pissarro and Monet fled to England during the Franco-Prussian War (1870). While there, the artists maintained contact, and Pissarro studied British landscape and portrait painters and experimented with painting English weather conditions. It was not until 1871–72, however, that his Impressionist style stabilized.

Entrance to the Village of Voisins (1872), done after Pissarro's return to Louveciennes, is a culmination of this early development. The strong composition of this village scene is typical, but the canvas is notably more colorful than previous works. The contrast of sunlit areas and shadows is pronounced, and form is defined by brushstrokes.

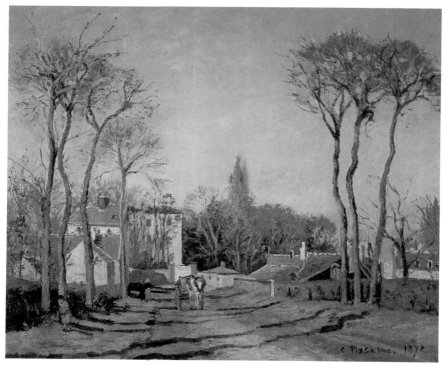

Pissarro, *Entrance to the Village of Voisins*, 1872

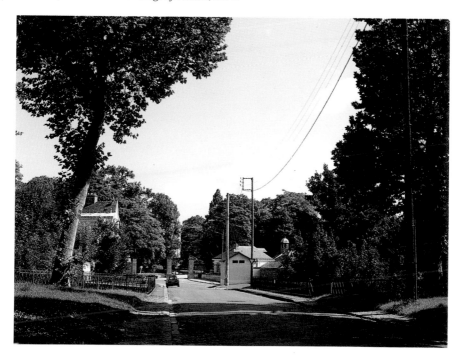

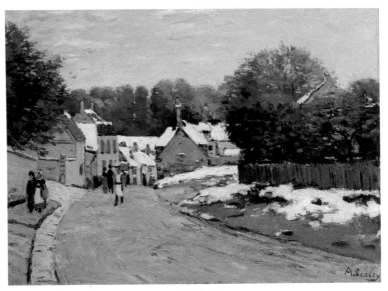

Sisley, *Early Snow at Louveciennes*, c. 1870–71

Return to rue de Voisins, cross the street, and turn left. Continue about halfway up the hill and turn around to view the site of Sisley's *Early Snow at Louveciennes*.

The next site is seen in a work by Sisley, **Early Snow at Louveciennes** (c. 1870–71). This painting exemplifies the Impressionists' taste for depicting the particular atmospheric effects of snow and winter light. The foreground is completely given over to another favorite Impressionist motif, a simple country road. Here its broad sweep carries the eye to a cluster of stone and stucco buildings.

Renoir, *Versailles Road, Louveciennes*, 1895

The next main road, route de Versailles, was taken as a subject by Monet, Pissarro, and Renoir. It is interesting to note that Renoir, even after he had become famous and successful for his portraits and figure studies, returned to the theme of country roads in his depiction **Versailles Road, Louveciennes** (1895).

Proceed straight ahead to route de Saint-Germain and look right to see a Renoir site (to the left the highway is called route de Versailles).

Route de Versailles to Parc de Marly

Turn left and walk down route de Versailles. Look for the Marly aqueduct on the right.

The architectural structure of the Marly aqueduct was built between 1681 and 1683, during the period when Louis XIV established his retreat at Marly. Almost 2,000 feet long, it is impressive even today.

Sisley painted **The Aqueduct at Marly** in 1874 in a composition that gives little hint of a more modern landscape. Using a restricted palette of repeating hues, he deftly brushed trees, raking shadows, clouds, and the aqueduct in a tight arrangement of curving bands.

As you continue along route de Versailles, you will pass the site of Pissarro's residence, No. 22, and the house of Renoir's sister at No. 18. It was along this road that Pissarro and Monet painted together in the winter of 1869.

Parc de Marly to the Abreuvoir

Continue on route de Versailles to the next major highway, route de Marly. Across the highway is the Musée Promenade.

Located in the Parc de Marly, between Louveciennes and Marly, is the Musée Promenade. On the park grounds of the Château de Marly, the museum displays a wealth of information about the history and artists of the area.

From the museum, walk down the cobblestone path through the Parc de Marly. Exit the park at avenue des Combattants, and turn right to reach the Abreuvoir.

The remainder of the tour is of Sisley sites in the small village of Marly-le-Roi. Sisley lived near the Abreuvoir, the horse trough at Marly, between 1874 and 1877, and he painted its unique and peaceful location, in good weather and bad, at least a dozen times during those years.

Circle the water, and stand facing the Abreuvoir with your back to the park. You will be in the same

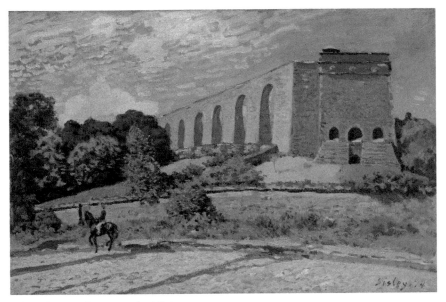

Sisley, *The Aqueduct at Marly*, 1874

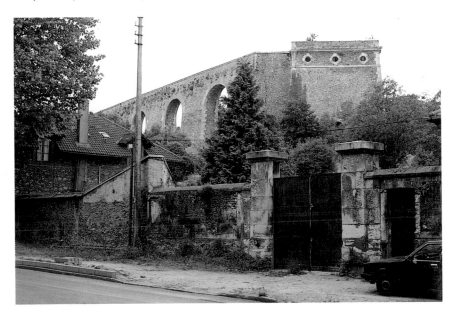

Sisley, *Watering Place at Marly-le-Roi*, 1875

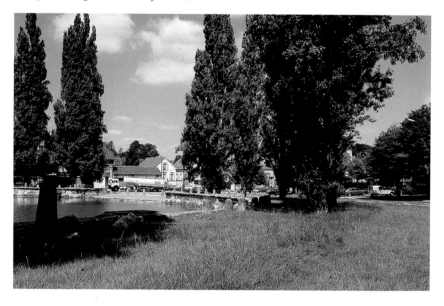

position as Sisley when he painted **Watering Place at Marly-le-Roi** (1875). This work focuses not on the architectural features of the Abreuvoir, but on the overall effect of high-keyed light on a bright summer day.

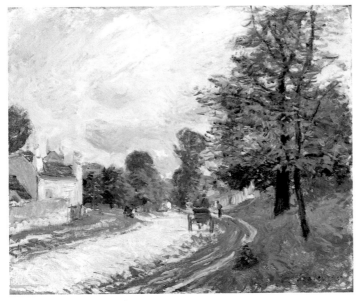

Sisley, *A Turn in the Road*, 1873

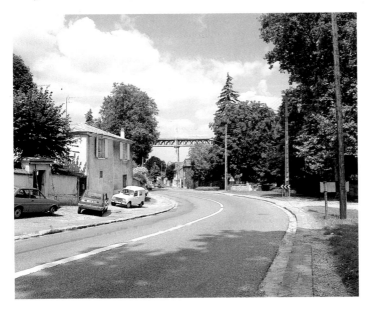

Avenue de l'Abreuvoir to Marly station

Sisley's home (now destroyed) was at No. 2, avenue de l'Abreuvoir, on the right side. As you walk, look for his view of **A Turn in the Road** (1873), and

Return to the main intersection, place de l'Abreuvoir, and head up avenue de l'Abreuvoir to the site

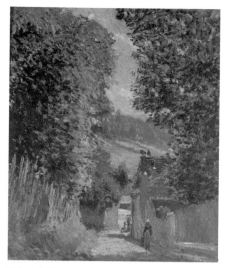 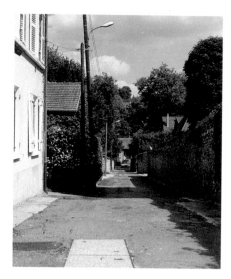

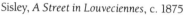
Sisley, *A Street in Louveciennes*, c. 1875

of Sisley's *A Turn in the Road*. A left turn onto rue de la Briqueterie, at the traffic light just before the train trestle, brings you to the site of another of his street scenes.

about halfway up the steep hill on rue de la Briqueterie, turn around to see the site of **A Street in Louveciennes** (c. 1875).

Sisley's Marly paintings show his ongoing study of light, atmosphere, and varying weather conditions. He altered his brushstrokes to build form, which he enhanced by contrasting warm and cool colors. Sisley carefully structured his compositions to show depth, using diagonal and vertical lines to control the eye.

Continue straight up the hill toward rue Alfred-Couturier and the Marly train station.

Sisley's work in Marly represents his mature Impressionist style. All during this period he tried to gain acceptance for his work. But despite its quality, when he left Marly in 1877, he had achieved neither recognition nor commercial success.

PORT-MARLY AND BOUGIVAL TOUR

The light flickering through the trees and shimmering on the Seine has not changed since the Impressionists painted this still-lovely area west of Paris. The most historically important location is the approximate site of both Sisley's and Pissarro's views of the Seine, and Monet's and Renoir's paintings done at the renowned and popular floating restaurant, La Grenouillère.

As you walk along the Seine, you will see the last remnants of the famous Machine de Marly (see p. 32). Also interesting are the still-active locks at Bougival, painted by Sisley and Pissarro. When looking at the calm, reflective Seine here, it is sometimes hard to realize that aside from bringing beauty to the countryside and cities of France, the Seine is also an actively used and carefully regulated waterway which connects Paris to the sea.

The highway bordering the Seine is noisy and busy, but the route is easy to walk and offers a wide variety of painting sites. Although most of the Sisley sites at the beginning of the tour were not painted during the early period of Impressionism, visiting Port-Marly and Bougival on the same trip is convenient. The tour is routed in reverse chronological order, but purists can easily reverse the order to its historical sequence.

The railroad from Paris to Le Pecq opened in 1837, and from the station at Chatou, the painters could take a horse-drawn shuttle to Bougival or other nearby painting locations. Today, buses and trains move over these old routes.

When you depart the bus at Port-Marly, you will be on a busy major highway, which changes names several times. In Port-Marly it is rue de Saint-Germain.

ITINERARY

TOUR TIME: half a day

There is no tourist office in Bougival or Port-Marly.

FARES
Paris to Saint-Germain-en-Laye (from Châtelet-les-Halles), one way: 10 Fr
Saint-Germain-en-Laye to Port-Marly: Pay with a Paris Métro ticket; stamp it upon boarding the bus.
Bougival to La Défense: two Métro tickets
La Défense to Paris (L'Étoile stop), one way: 5.40 Fr

To go to Bougival, take the RER (regional express network) A (red) line from Paris to Saint-Germain-en-Laye; use a ticket machine to buy a one-way ticket. Save it; you will need it to exit the station.

The RER trains are fast, frequent, very clean, and sometimes crowded. Try to avoid rush hours and late-night hours. The trip to Saint-Germain-en-Laye takes about 30 minutes.

To exit the Saint-Germain-en-Laye station, follow the sign to place du Château, côté rue de la Salle, and continue through the arcade area (the Parc Auto 1 is to your left; escalators and stairs to rue de la Salle are straight ahead).

At street level, turn left. Before crossing the street, go about 60

paces to the right. You will see the local buses on your left. Take bus I58A to the Port-Marly Jean Jaurès stop.

One option will save thousands of footsteps; you can reboard the bus on the main highway bordering the Seine at any point you choose—you may miss portions of the tour, but will arrive back in Paris slightly less fatigued.

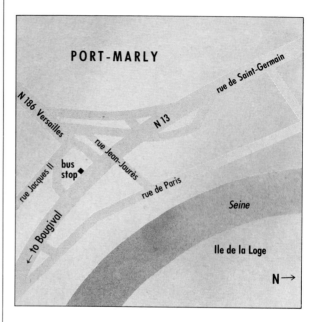

Rue de Saint-Germain to Rue Jean-Jaurès

Exit the bus and walk to the right (northwest) on rue de Saint-Germain, then left at rue Jean-Jaurès. Continue almost to the end of this short, slightly uphill street and cross to the right side.

Near the end of rue Jean-Jaurès, to the south, is the site of Sisley's **Marketplace at Marly** (1876). Although the street today is paved and has traffic, signs, TV antennae, and many parked cars, the roof line and uphill slope of the road are the same as when Sisley painted it. The work is characteristic of Sisley's style at the time. His solid buildings contrast with airy clouds, and in typical Impressionist treatment, the people are no more or less important than any other element of the painting.

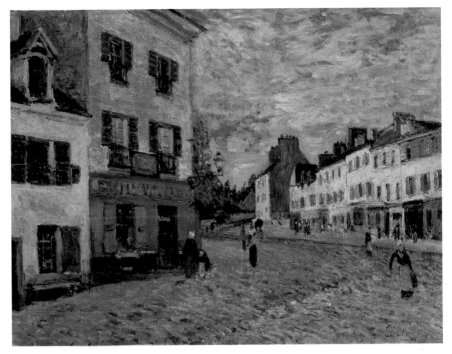

Sisley, *Marketplace at Marly*, 1876

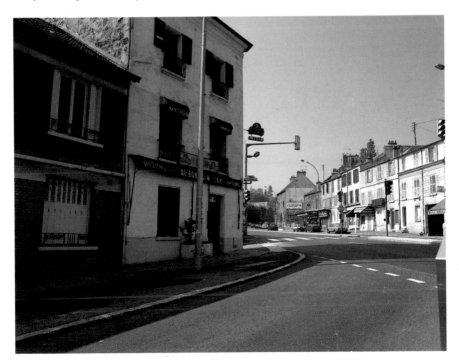

Backtrack downhill on rue Jean-
Jaurès; cross the main highway,
continuing downhill on the right
side to rue de Paris. Stop just
before the intersection and look
left to see the site of Sisley's
flood series.

The area at the corner of rue de Paris and rue
Jean-Jaurès is the site of Sisley's famous series docu-
menting the flooding Seine. The restaurant building
featured in the paintings still exists today, but is
now a tobacconist's.

Sisley carefully studied every nuance of the
unusual atmosphere created by the flood condi-
tions; each painting has a slightly different quality
of light, and each shows the ever-changing move-
ment of water, clouds, and boaters. Sisley first
painted this theme in 1872; **Boat during the
Flood, Port-Marly**, one of six pictures he created
in 1876, is a study in reflection: the pale hues of the
sky and clouds are mirrored in the seemingly tran-
quil waters. Although the trees have grown and the
water has receded, the calm mood that Sisley
depicted still exists today.

Rue de Paris to Bougival locks

Backtrack again to rue de Saint-
Germain. Cross the street and turn
left (southeast, toward Bougival).
Walk along this busy road for
about 15 minutes to the Hostellerie
du Coq Hardi (see map, p. 35).
Cross the street at the traffic sig-
nal. Just ahead to the left, take the
unmarked uphill road to an over-
pass to Ile de la Loge. Stop
midway across for an excellent
view of the area.

As you approach Bougival, you can see the site
where the huge water wheels of the Machine de
Marly once operated, part of the system devised
during Louis XIV's reign to pump water uphill from
the Seine to his château at Marly. From the old bridge
crossing to Ile de la Loge, look south and up into
the hills of Louveciennes. You will see the location
of Sisley's *Louveciennes, Hilltops at Marly* (c. 1873).
Sisley approached this site from the opposite direc-
tion (see p. 18), but it is interesting to view, and it
might give you a better understanding of the geog-
raphy of the area. Sisley was living in the hamlet of
Voisins in Louveciennes, only a few minutes away.

Continue over the bridge and curve
to the right. Follow the sign,
"écluses de Bougival," to view
the locks.
Continue walking, and within 3
minutes you will arrive at an old
pedestrian bridge (rue Passerelle).

A short walk takes you along the Bougival locks.
Don't miss this. The view of the Seine is visually
exciting, and it is fun to watch the boats in this
active area. The locks, built in 1838, were the first
of a series of waterworks installed along the Seine
to control its erratic flow.

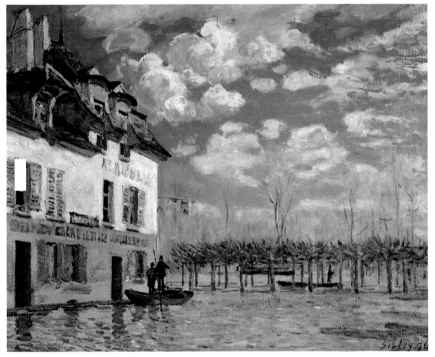

Sisley, *Boat during the Flood, Port-Marly*, 1876

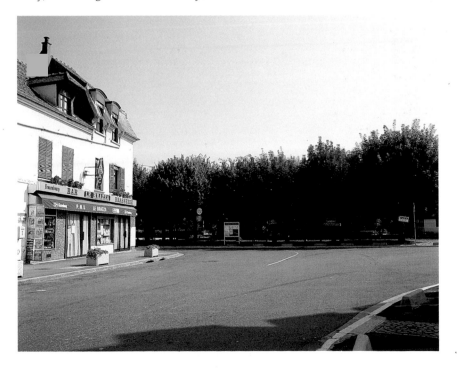

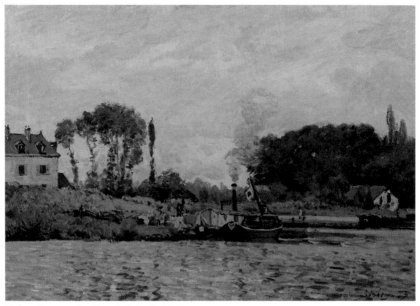

Sisley, *Boats at the Bougival Lock*, 1873

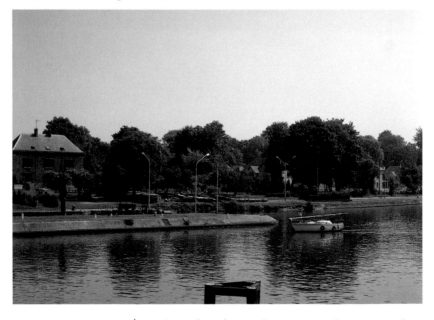

Midway across, to the left (north), is the site of Sisley's *Boats at the Bougival Lock*.

An early Sisley work, **Boats at the Bougival Lock** (1873), was painted here; the house to the left still exists. Sisley's main interest was not the picturesque aspect of the river but its role as a vital conductor of traffic.

BOUGIVAL

Hostellerie
du Coq Hardi

chemin de la Machine

to Port-Marly →

quai Rennequin Sualem

Machine
de Marly

bridge

Île de la Loge

Passerelle

locks

Seine

N 13

quai Boissy d'Anglas

Île de la Chaussée

Bougival bridge

Ave. J.-B. Charcot

Croissy

rue du Général-Leclerc

rue J.-Kellner

quai G.-Clémenceau

■ stadium

Montrival

rue I.-Tourguenief

Île de Croissy

route de la Source

B.-Morisot

■
bus
stop

Closeaux

N→

Ile de Croissy to Seine footpath

Continue across the bridge to the mainland. Go left on quai Boissy-d'Anglas to the Bougival bridge (Pont Mal-de-Lattre-de-Tassigny), the next major overpass. Use the pedestrian steps with metal railing and cross the bridge to Ile de la Chaussée. Take the paved road marked "Ville de Bougival Parc de la Chaussée" to your right; follow the road to the south, almost to the riverbank, to view the site of Monet's *The Seine at Bougival*.

Ile de Croissy, also known as Ile de la Chaussée, is one of three long narrow islands in this bend of the Seine. In the late 1800s, its lush greenery and open spaces made it a popular site for cafes and inns frequented by weekend visitors. Painted from the island's south shore, Monet's **The Seine at Bougival** (1869) looks across a bridge (its main span is now gone) toward Bougival. Portions of this early painting seem momentarily bathed in sunlight, despite the overcast day. His wet-into-wet brushstrokes are short and clear. Small dabs of pure color are balanced with broader portions of mixed warm and cool hues. (A portion of the old bridge still exists as avenue Jean-Baptiste Charcot, as does the fence on the right.)

Backtrack across the Bougival bridge to the mainland. Continue left at the water's edge on quai Georges-Clemenceau (the name changes to rue Ivan-Tourguenief), about 15 minutes. Turn left at rue Berthe-Morisot to reach the Seine. Walk 5 minutes farther to the right to rue des Closeaux. There look across the water to the Ile de Croissy.

The placid waters between Bougival and Ile de Croissy offered a berth for the famous and somewhat notorious floating restaurant, La Grenouillère. This site has often been celebrated as the birthplace of Impressionism for the works created here in 1869 by Monet, although evidence of his adoption of light and moment as subjects can be seen in earlier efforts. He and Renoir, most likely working side by side, each painted three La Grenouillère canvases depicting the carefree cafe crowd, boaters, and swimmers. Unfortunately the passage of time has modified this area significantly. The cafe burned down long ago, and dredging of the river has obliterated key identifying characteristics of the site.

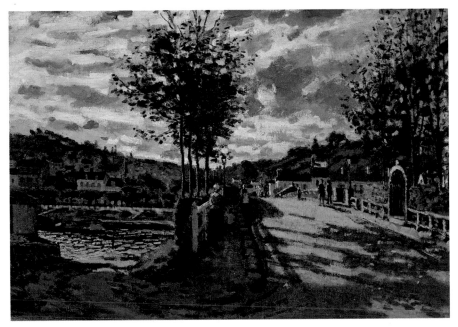

Monet, *The Seine at Bougival*, 1869

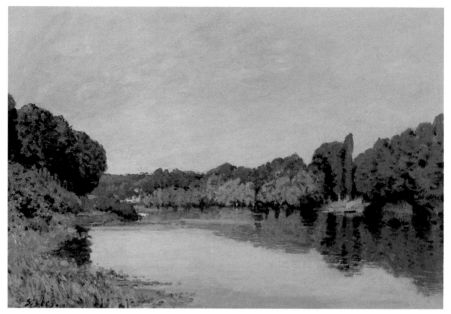

Sisley, *The Seine at Bougival*, 1872–73

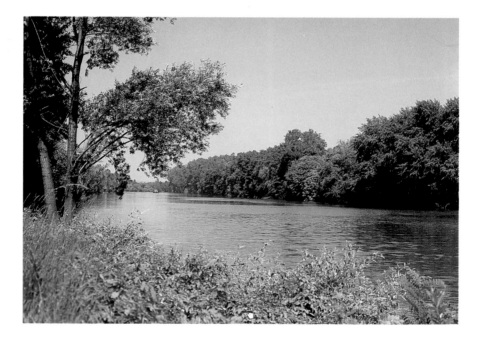

This section of the river is also the probable location of Pissarro's *Wash House at Bougival* (1872) and Sisley's **The Seine at Bougival** (1872–73). Unlike those of Monet and Renoir, Sisley's view of the usually busy waterway is surprisingly free of boats and offers no hint of weekend visitors.

If you walk to the right for about 10 minutes on the Seine footpath, you will come to a restaurant, and beyond it a metal platform that reaches a little over the water. Here you can enjoy a more expansive view of the Ile de Croissy.

This last viewpoint is not an exact painting site, but standing here, observing the sparkle of sunlight on the river, verdant trees, and shimmering sky, it is easy to understand why this area on the banks of the Seine, as well as the hills of Louveciennes, became the birthplace of Impressionism.

Return to the south side of rue Ivan-Tourguenief and the Maison Rouge bus stop, between rue Berthe-Morisot and rue des Closeaux. Take bus 158A to La Défense, a 25-minute trip. From there take the A (red) line of the RER train in the direction of Boissy-Saint-Léger or Torcy to return to Paris. The station is well marked. Save your ticket to exit.

Fontainebleau's Villages

The Impressionist movement is intrinsically connected to Fontainebleau Forest. Almost every artist mentioned in this book visited there, starting in the 1830s, when a small group of artists, collectively known as the Barbizon School, ventured to Fontainebleau to observe and paint directly from nature. They were interested in capturing the effects of natural light and atmosphere in the dense gold-green of these woods.

Only Jean-François Millet and Théodore Rousseau lived permanently in the small village of Barbizon, but Jean-Baptiste Corot, Charles-François Daubigny, and Gustave Courbet went there often to paint the rural beauty and serenity of preindustrial France.

The artist population of Barbizon swelled after the railroad to Fontainebleau opened in 1849. By the 1860s, this previously isolated retreat from Paris had become a haven for landscape painters and tourists alike. In the spring of 1863 and again in 1865, Monet, Sisley, Renoir, and Bazille came to the now-crowded forest. (Pissarro purportedly joined them in 1865, and Cézanne ventured there in 1879–80.) With maps to guide them, these young artists found and painted many of the sites in Fontainebleau depicted by their predecessors.

Only Sisley returned permanently to the area. In 1880, he moved to Veneux-Nadon, a small village on the southeastern edge of the forest. Low

rents and glistening water led him back to Moret-sur-Loing in 1882, Veneux-les-Sablons in 1883, and finally permanently to Moret in 1889 Except for short stays elsewhere, Sisley concentrated his artistic energy for the last nineteen years of his life in these picturesque villages.

Although they do not aesthetically or technically surpass his previous work, Sisley's Saint-Mammès and Moret canvases are classic examples of his Impressionist style. Despite abject poverty and relative obscurity, Sisley continued expertly and sensitively to paint serene, reflective water; atmospheric, cloud-filled skies; and intimate country landscapes.

Pissarro was the only other Impressionist painter to revisit Fontainebleau. During 1902, near the end of his life, he painted in Moret, capturing the tranquil waters of the Loing. Pissarro rarely recorded water, and it is noteworthy that even late in his career, he was exploring new motifs.

Many fine examples of the Impressionists' early works are set in Fontainebleau Forest, but not one of these sites is accessible by train, and many no longer bear any resemblance to their original state. I chose rather to take the train to Saint-Mammès to explore sites in the charming villages on the forest's southeastern edge.

ITINERARY

TOUR TIME: half a day

MORET TOURIST OFFICE
Place de Samois
Tel: 60-70-41-66

FARES
Paris to Saint-Mammès: 82 Fr

To go to Moret and Saint-Mammès, take the train that goes to Montereau from Gare de Lyon. Departure times are listed near the ticket counter; the train usually leaves from platform K at roughly 90-minute intervals starting at 8:30 a.m. (check the schedule for return times).

The trip takes about 55 minutes. The train will stop briefly in Moret just 3 minutes before reaching the tiny station at Saint-Mammès.

SAINT-MAMMÈS AND MORET-SUR-LOING TOUR

Visit the tiny, medieval hamlets of Moret and Saint-Mammès on a day when your soul wants nourishment. The train from Paris will take you through Fontainebleau Forest.

Sisley picked an idyllic location in which to live and paint, and despite modernization, the Seine-et-Marne district is a delightful mixture of old and new. Much of what Sisley and Pissarro captured appears today as it did 100 years ago.

Study the maps of the adjoining villages before starting out. (The railroad bridge is a handy orientation point.) This tour takes you to riverside locations along the Seine and both the Saint-Mammès and Moret banks of the Loing.

You can complete the tour in half a day, but you might plan on staying the entire day. The tree-lined banks of the Loing offer almost an infinity of greens, browns, and yellows to admire. The pinks and blues reflected by Moret's historic bridge and mill are equally spectacular. Take extra film for your camera, a picnic lunch, and a sketch pad.

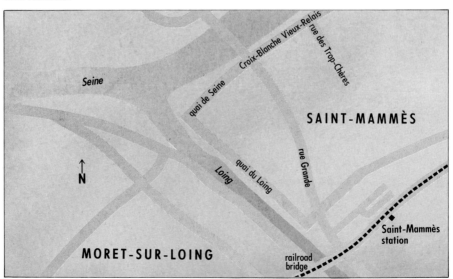

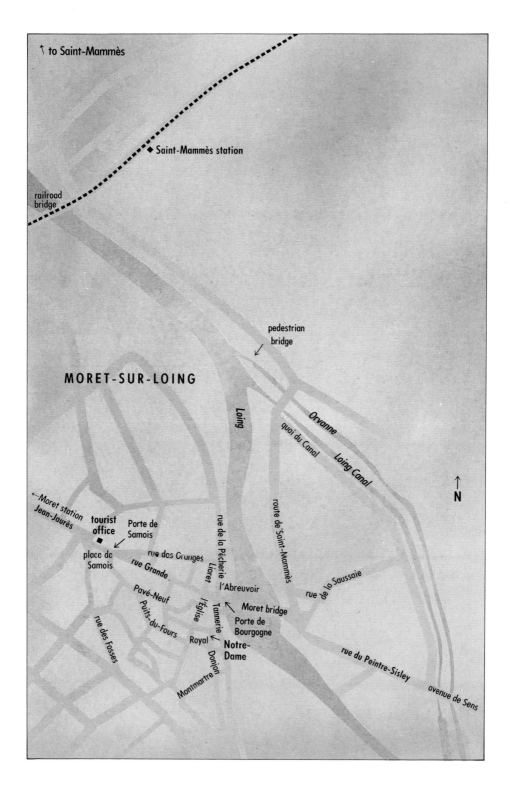

↑ to Saint-Mammès

◆ Saint-Mammès station

railroad
bridge

pedestrian
bridge

MORET-SUR-LOING

Loing

Orvanne

quai du Canal

Loing Canal

↑
N

route de Saint-Mammès

←Moret station
Jean-Jaurès

**tourist
office**

Porte de
Samois

place de
Samois

rue des Granges

rue Grande

rue de la Pêcherie

Lioret

rue de la Saussaie

l'Abreuvoir

Pavé-Neuf

Puits-du-Fours

l'Église

Tannerie

↖ Moret bridge

Porte de
Bourgogne

rue des fosses

Royal ↖

**Notre-
Dame**

Donjon

rue du Peintre-Sisley

Montmartre

avenue de Sens

Rue Grande to Rue Vieux-Relais

At Saint-Mammès, exit the train on the side opposite the station. Find a dirt path that parallels the tracks and follow it to its intersection with a paved road. Go left, and almost immediately, turn right onto the main road, rue Grande.

At the Seine, turn right onto quai de la Croix-Blanche (the sign is difficult to find). Continue to No. 41, rue Vieux-Relais, the same street; its name changes (you've gone too far if you pass rue des Trop-Chères). Pass through the archlike entrance at No. 41 and turn around to view the site of Sisley's *Farmyard at Saint-Mammès*.

The first Sisley site is found by walking downhill along rue Grande to the Seine.

Sisley first met Monet, Renoir, and Bazille in Charles Gleyre's studio in 1862. He painted with them in 1863 and 1865 in the Fontainebleau Forest and, in 1866, with Renoir at Marlotte. An integral part of the group of artists active in the Ile de France in the 1870s, he was a frequent participant at the regular gatherings officiated by Monet at the Café Guerbois in Paris. He participated in the first official Impressionist exhibition of 1874 as well as those of 1876, 1877, and 1882.

Although Sisley is better known for his sensitive depiction of life along the banks of the Loing and Seine, the intimate country scene in **Farmyard at Saint-Mammès** (1884) is typical of his painting style, with its intriguing use of varied brushstrokes to emphasize the differences between sky, foliage, and buildings. People become simply another element of the painting, like the sky or the shrubbery.

The activities of farm workers in the foreground are just one element of the scene. Sisley invites the eye to look farther, to what lies beyond; his understanding and use of perspective allow him this control. Without using extremes of light and dark, Sisley captured both the flickering of the foliage and the billowing of the clouds, yet did not sacrifice the concreteness of the building. Like Cézanne, he maintained a concern for showing the solidness of form throughout his career.

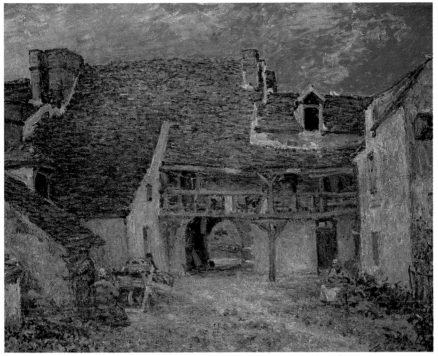

Sisley, *Farmyard at Saint-Mammès*, 1884

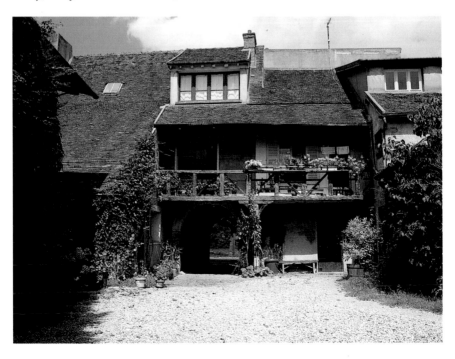

Quai de la Seine to Quai du Loing

Return to the street, turn left, and backtrack with the Seine on your right. Cross rue Grande and continue straight on quai de la Seine. When the quai abruptly turns left, before turning, walk straight to the water's edge to take in the view. Then follow the quai to the left.

After leaving the farmyard site, follow directions to the confluence of the Loing and Seine rivers. The essence of this area has changed little since Sisley studied and painted the luminous water, cloudy skies, and blue-green hills.

Walk left along the Loing river. Sisley frequently painted the bank you are on from the Moret side. All along the water are barges, houseboats, and men fishing, unhurried yet productive. The houses dotting the bank are still similar to those Sisley depicted.

As you walk along, the quai road will become unpaved. Shortly after passing under a railroad bridge, you will reach the confluence of the river, the Loing canal, and the Orvanne River. Cross the Orvanne on the concrete pedestrian bridge with a metal railing. Look down the path to see the view of Sisley's *Avenue of Poplars near Moret.*

Soon you will approach the confluence of the Loing and the Loing canal (also known as the Bourgogne canal), a vital link between the south of France and Paris. Here you will find the site of Sisley's **Avenue of Poplars near Moret** (1890). The scene remains remarkably similar to Sisley's lovely rendition. Notice the still-present house on the left, the row of trees, and the gentle path.

Sisley greatly favored this picturesque byway. He frequently set up his easel in the direction of the river in order to depict the riverbank and the top of the Moret church.

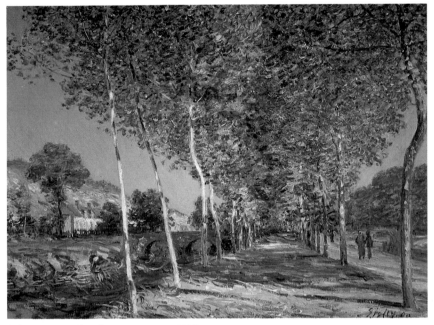

Sisley, *Avenue of Poplars near Moret*, 1890

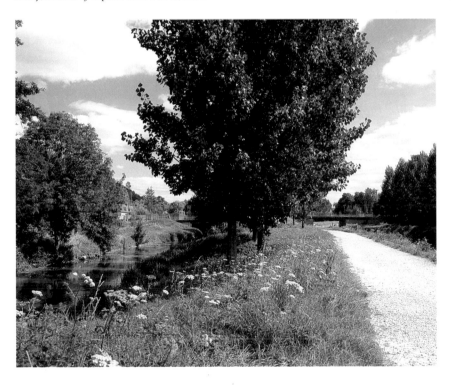

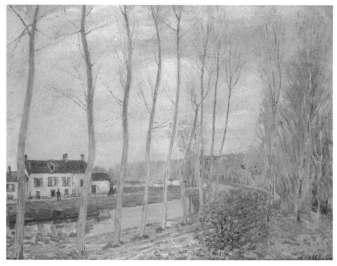

Sisley, *The Loing Canal*, 1892

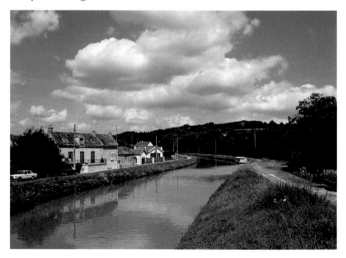

Loing canal to Rue du Peintre-Sisley

Continue down the path, and cross the canal on the metal walkway over the lock and turn left, onto quai du Canal. (If the lock is open, backtrack and cross via the car overpass.) Proceed to rue du Peintre-Sisley. Ascend the bridge here and look back at the path you just walked; this is the site of *The Loing Canal*.

Like all the Impressionists, Sisley was fascinated by the motif of water. The composition of **The Loing Canal** (1892) is unusual in that the bare trees (gone today) block what would be his usual expansive view. Yet he still maintained a sense of perspective and movement with the curved road and the bend in the canal, which forces the imagination beyond the scope of the painting.

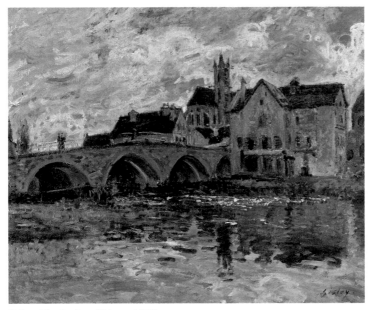

Sisley, *The Bridge of Moret*, 1887

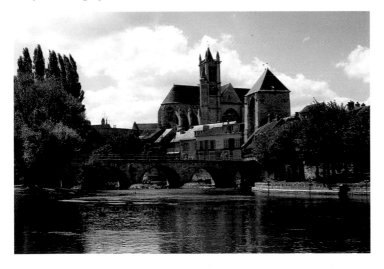

You next arrive at Moret's famous Loing River bridge and mill (both reconstructed after World War II), the twelfth-century gate of Bourgogne, and the peaceful river itself. While living at Veneux-les-Sablons, Sisley painted **The Bridge of Moret** (1887). In all, Sisley painted at least thirty different views of Moret and the bridge between 1887 and

Now turn left and walk 5 minutes along rue du Peintre-Sisley toward the Loing and Moret.

Before crossing the bridge over the Loing, go right to a large grassy area and walk left to the bank of the river.

1895. Typical of his style, in these works the water appears to shimmer as it flows, while the structures maintain a sturdy, solid appearance. Despite changes in architecture and foliage, the scene remains as inviting today as it was when Sisley stood here almost a century ago.

Porte de Bourgogne to Loing railroad bridge

From your vantage on the Moret side of the Loing, look across the river to the white cliffs featured in Pissarro's misnamed **Moret, the Loing Canal** (1902). The aging artist traveled with increasing frequency toward the end of his life, searching out new themes. This canvas is one of his few water scenes, and Pissarro superbly captured the idyllic atmosphere. People still fish here and amble along the dirt path.

Sisley's *At the Bank of the Loing* (date unknown), which features fat white ducks, also could have been done at this location. (As I stood enjoying the pastoral scenery, at least a dozen fat white farmyard ducks made a noisy appearance!)

Cross the bridge, go through the Porte de Bourgogne, and immediately make two rights on rue de la Pêcherie and rue de l'Abreuvoir, to the water's edge. To the left, a 10-minute stroll along the river past a boat restaurant brings you almost to the railroad bridge.

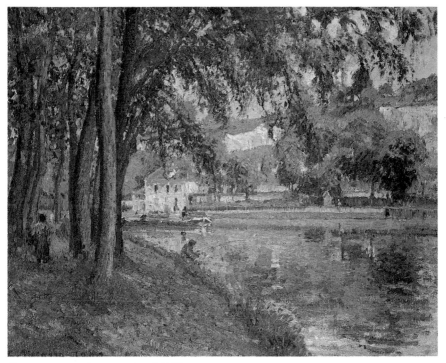

Pissarro, *Moret, the Loing Canal*, 1902.

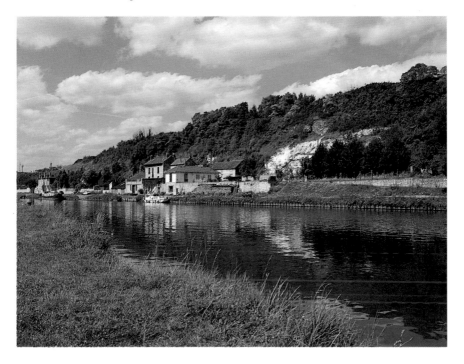

Notre-Dame Church

Backtrack to the Moret bridge and rue Grande; turn right and immediately left on rue de l'Église. Continue to rue Puits-du-Fours and turn around to face the church.

The wooden structure Sisley depicted in **The Church at Moret** (1893) has been replaced by parking spaces, but the church, consecrated by Thomas à Becket in 1166, remains in its original form. Possibly inspired by Monet's Rouen Cathedral series of 1892–93, Sisley painted a dozen views of Notre-Dame between 1893 and 1894. This church was a vehicle for Sisley's never-ending study of different weather conditions and the effects of varying light on elements of composition.

Sisley's home to Moret station

To reach Sisley's house, traverse the place Royal alongside the church, and behind it, go right on rue du Donjon.

The last stop is the house in which Sisley lived during the last four years of his life. The house, surrounded by a high wall on the corner of rue du Donjon and rue Montmartre, is marked with a plaque.

To leave Moret, return to rue Grande, turn left, and walk approximately 20 minutes through the quiet village, passing through the Porte de Samois and continuing on the main road (its name changes) to the train station (Moret-Veneux-les-Sablons).

Although somewhat sociable during his Parisian years, Sisley, embittered by lack of success, spent his last years surrounded by the quiet beauty of these villages, yet he was very much alone. Possibly he never achieved renown because he was not an innovator, as was Monet. No major art movement developed from his work, as from Cézanne's and van Gogh's, nor did he tackle the difficulties of the human figure, like Renoir; neither was he an emotional leader and father-figure, as was Pissarro. Yet no other artist of this group mastered landscapes of daily life with such richness and subtlety.

A last note: Sisley painting sites exist at nearby Veneux-Nadon and By, but you must have a car to reach them. Contact the exceptionally helpful tourist office staff in Moret (tel. 60-70-41-66) about the possibility of hiring a guide.

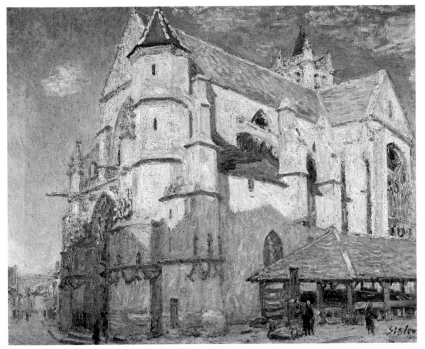

Sisley, *The Church at Moret*, 1893

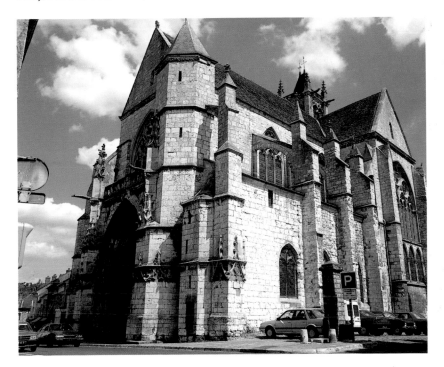

The Rural Landscape

The best-known Impressionist artists of the Pontoise–Auvers-sur-Oise area are Berthe Morisot, Camille Pissarro, Paul Cézanne, and Vincent van Gogh, who all came to this area some 20 miles northwest of Paris at different stages of their artistic development.

The first to arrive was Berthe Morisot. Eager to paint outdoors, she shared a house with her sister Edma in 1864 in Chou, a tiny hamlet between Auvers and Pontoise. Only one landscape from this period survives, *Old Lane at Auvers*. Later, in 1873 and again in 1874, she lived with her sister in Maurecourt, near Auvers, and in Chou.

An extremely talented painter even at this early period, Morisot captured the qualities of early morning light with an accuracy and sensitivity readily respected and acknowledged by her peers. Although none of her painting locations are recognizable, it is interesting that she chose this area to begin her outdoor painting explorations as she turned from the romantic naturalism of the Barbizon style to a growing interest in Impressionism.

Pissarro, the next to come, stayed the longest, painting in the Pontoise area for twenty years. Many of his finest paintings were done in the Hermitage section of Pontoise. He loved the rural landscape and after 1871 became an interpreter of country life, intent on showing people in harmony with their natural setting. His intimate country scenes celebrate the wholesomeness and unpretentiousness of peasants working, strolling, or just sitting among trees and flowers.

Cézanne was persuaded twice by Pissarro to visit Pontoise and Auvers. These periods, 1872–74 and 1879–82, were times of dramatic change in his painting style. Particularly in 1872–74, under Pissarro's influence, he lightened his palette, changed his subject matter, and for the first time painted outdoors, a practice he held to from that time on. Cézanne's Pontoise and Auvers paintings laid the foundation for his later masterpieces.

The last famous artist to paint in this area was van Gogh. In 1890, released from an asylum in Saint-Rémy, he moved to Auvers at the suggestion of his brother Theo. Seventy days and seventy-three canvases later, van Gogh ended his life by suicide. Although for several years van Gogh had been painting emotional, color-laden canvases, he used his time in Auvers to further explore this artistic path. His last paintings are fresh and dynamic, executed with vigorous brushstrokes.

Two other artists who came to Auvers were sources of inspiration for the young Impressionists. The first, Charles-François Daubigny, was a member of the Barbizon School. He had tired of Fontainebleau Forest, and after working with the Saint-Siméon group of the Normandy coast (see p. 98), he moved to Auvers in 1860, where he spent most of the rest of his career near the Seine and Oise rivers. Daubigny impressed upon the young painters, particularly Monet and Sisley, his love of glimmering water. He was the first Barbizon painter to advocate completing paintings outdoors (rather than in the studio); Corot also told the younger painters to return often to their painting sites. In 1857 Daubigny built a studio-boat (as did Monet several years later) in order to catch every nuance of the water he sought to depict. His home in Auvers was a gathering place for Morisot, Monet, Sisley, Pissarro, Cézanne, Renoir, and his old Barbizon friends Corot, Courbet, and Millet.

The second artist, a gifted amateur, was the physician Paul-Ferdinand Gachet, who had assumed the task of watching over van Gogh. Gachet was an early admirer and patron of the young Impressionists, who came to sit in his garden, view the Oise, and discuss art. The doctor practiced medicine in Paris three days a week, but his house was always open to his artist friends.

ITINERARY

TOUR TIME: one day

PONTOISE TOURIST OFFICE
Place du Petit-Martroy
Tel: 30-38-24-45

MUSÉE PISSARRO
Hours: Wed.–Sun., 2–6 p.m.

MUSÉE TAVET
Hours: 10 a.m.–noon, 2–6 p.m.;
closed Tues. and holidays

FARES
Paris to Pontoise: 36.80 Fr

To go to Pontoise, take the train
from Gare Saint-Lazare, platforms
8–12. Purchase a round-trip ticket
from an automatic ticket machine.
Keep the ticket; you will need it to
exit the station at Pontoise.

PONTOISE TOUR

Pontoise is considered a suburb of Paris, yet the influence of the nearby capital has been kept to a minimum. Despite the proliferation of new homes and industrial buildings, you will find much of the area still retains the rural character Pissarro so deftly captured.

This long excursion requires an abundance of energy, but completing the entire tour will give you an understanding of the man Pissarro and his art, and of the location that occupied his canvas for the better part of twenty years. For those wishing to make a shorter tour, consult the map for convenient return points to the train station.

Two streets—rue Maria-Deraismes and rue de l'Hermitage—are essential in finding tour locations. It will be helpful if you first use the map to orient yourself to them.

Try not to miss the Musée Pissarro and the panoramic view from the adjacent park. The museum has few Pissarro paintings but usually a worthwhile current exhibition. The Musée Tavet is also impressive and has interesting temporary exhibitions.

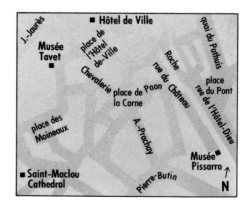

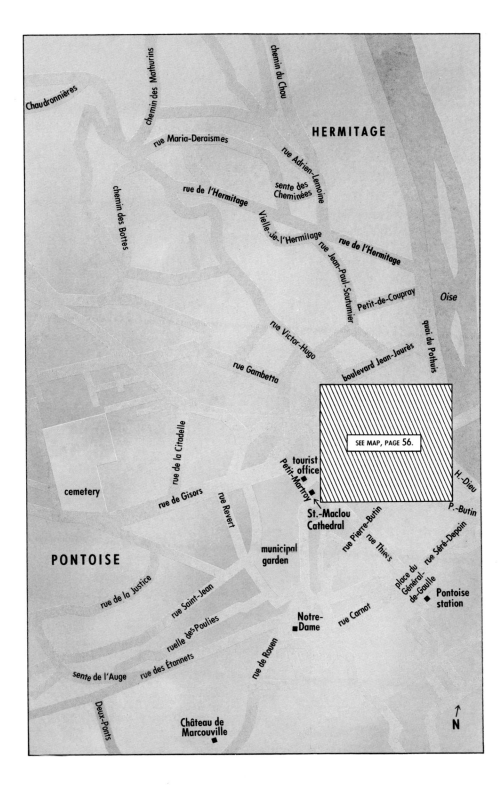

Chaudronnières

chemin des Mathurins

chemin du Chou

rue Maria-Deraismes

HERMITAGE

rue Adrien-Lemoine

sente des Cheminées

rue de l'Hermitage

chemin des Bottes

Vieille-de-l'Hermitage

rue de l'Hermitage

rue Jean-Paul-Soutumier

Petit-de-Coupray

Oise

rue Victor-Hugo

quai du Pothuis

rue Gambetta

boulevard Jean-Jaurès

rue de la Citadelle

SEE MAP, PAGE 56.

cemetery

rue de Gisors

rue Revert

tourist office

Petit-Martroy

H.-Dieu

St.-Maclou Cathedral

P.-Butin

PONTOISE

municipal garden

rue Pierre-Butin

rue Thiès

rue Séré-Depoin

rue de la Justice

rue Saint-Jean

ruelle des Poulies

Notre-Dame

rue Carnot

place du Général-de-Gaulle

Pontoise station

sente de l'Auge

rue des Étannets

rue de Rouen

Deux-Ponts

Château de Marcouville

N

Pontoise station to Chemin du Chou

Exit the Pontoise station. Walk through the square, place du Général-de-Gaulle, to the first street on the right, rue Séré-Depoin. In a few moments you will reach the Oise. With the water on your right, walk along quai du Pothuis and follow the signs to the Hermitage, about a 10-minute walk. At rue de l'Hermitage, turn left. Walk a short distance to the first street on the right, rue Adrien-Lemoine. Turn up this steep hill; at No. 24, rue Adrien-Lemoine, veer right onto an unmarked, badly paved path, chemin du Chou. Just past the stone fence, look to the right into a typical Pissarro garden location.

Pontoise in the fourteenth century was the capital city of the area known as the Vexin, but by 1866, its influence long since eroded, Pontoise had become an unimportant, lovely, simple farming community where Parisians ventured for country outings.

For Pissarro, Pontoise offered a tranquil pastoral environment and considerable visual interest, especially in the hamlet area of the Hermitage, yet was close to Paris, enabling him to maintain valued relationships with his artist friends. Although the Hermitage has changed considerably, remnants of what Pissarro recorded still exist today.

Nearly all of Pissarro's paintings from his Pontoise years feature the town's landscape. The garden area off the chemin de Chou is reminiscent of the bucolic *Kitchen Garden at the Hermitage* (1879) and **The Wheelbarrow, Orchard** (1881). He painted another work, *Kitchen Garden and Flowering Trees, Spring, Pontoise* (1877), from the field (now a garden) to the right; the house at No. 15 is featured in the painting.

It is Pissarro's contribution to Impressionism that he depicted peasants and rural landscapes without sentimentality, but with a pictorial naturalism that was one of his artistic strengths. These sparkling canvases are filled with short, paint-laden strokes of pure, unmixed color, and are important examples of Pissarro's Impressionist technique as well as of his Impressionist preference for depicting the world as it is. Typically, Pissarro's back was to the Oise, in direct opposition to the river views his friends probably would have chosen.

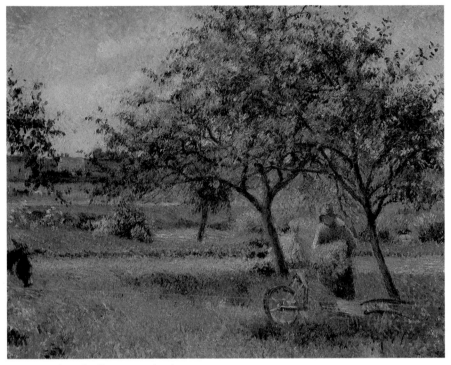

Pissarro, *The Wheelbarrow, Orchard*, 1881

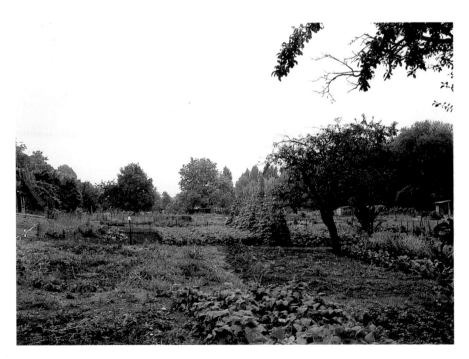

Rue Maria-Deraismes

Backtrack to rue Adrien-Lemoine, and proceed to the tiny sente des Cheminées on the right. It is across from No. 18, rue Adrien-Lemoine and to the right of No. 11. Climb a short distance to the crest. Pissarro lived to the right at the top; there is no number.

Continue on the footpath to the first street, rue Maria-Deraismes (not marked).

Rue Maria-Deraismes was the original path that curved through the village. Pissarro's friend Maria Deraismes, the feminist author for whom the street is named, lived nearby at the Château des Mathurins. Her elegant gardens inspired some of the few domesticated landscape scenes painted by Pissarro.

The site of the corner house on the right, No. 3, rue Maria-Deraismes, is the probable location of Pissarro's residence when he first arrived in the Hermitage in 1866. He lived here with his mistress (who later became his wife) and their two children. When he returned again in 1872–73 from England, where he had sought refuge during the Franco-Prussian War, Pissarro settled on a newer paved street, residing at No. 10 and later at No. 16. (This street no longer exists, according to Madame Cayrol of the Musée Tavet; the streets in the Hermitage district have altered greatly in the last 100 years.)

During the following years, he consistently painted the houses, gardens, and hills along or near the older road. The complex topography of this hilly area offered Pissarro a wide variety of easily accessible motifs. On foot, he could transport canvas and paint to a site as often as necessary.

Rue Vielle-de-l'Hermitage to Rue de l'Hermitage

Walk back to rue de l'Hermitage. Turn right, and almost immediately on your left will be rue Vielle-de-l'Hermitage. Turn left, and on the right by the second gravel road are two Pissarro sites.

Pissarro favored the hillside locations of the côte des Boeufs, to the left, and the côte de Jalais, to the right. He returned several times in different seasons to record the country dwellings with brightly tiled roofs near his home. The original cluster of houses still exists, the foliage still glistens, and the country atmosphere lingers.

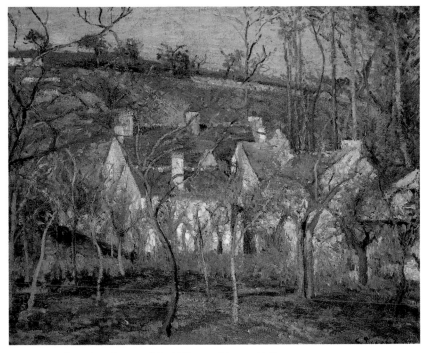

Pissarro, *Red Roofs, a Corner of the Village in Winter*, 1877

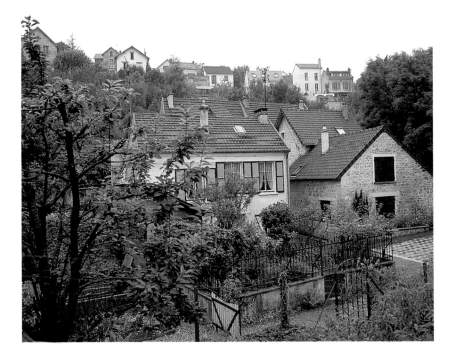

Red Roofs, a Corner of the Village in Winter and *Côte des Boeufs* (both painted in 1877) reflect Pissarro's respect and love for the French countryside. Pissarro recorded the village's blend of old and new; irregularly shaped eighteenth-century houses capped with nineteenth-century tiles portray the area in transition. *Red Roofs*, with its reds and greens, is a superb example of juxtaposed complementary colors, an important Impressionist technique. Pissarro was sufficiently pleased with this painting to exhibit it in the third Impressionist exhibition of 1877.

Rue de l'Hermitage to Chemin des Mathurins

To the right, at No. 46, rue de l'Hermitage, is the site of Pissarro's *Pontoise, Village of the Hermitage* (1873). This location is also reminiscent of Pissarro's *Hillside in the Hermitage, Pontoise* (1873).

Although the Hermitage still reflects the character that attracted Pissarro in the 1870s, it is remarkable to realize that, merely a century ago, he could ramble through these hills quickly, unimpeded by today's roads and structures. The côte des Boeufs, côte des Grouettes, and the fields on either side of rue de Gisors (see below) were only 10 minutes from his home. It required physical endurance to carry canvases to these diverse sites and to paint in every kind of weather. It also took emotional endurance for Pissarro to pursue an art form not readily accepted by a buying public.

The Ennery Road near Pontoise (1874) was painted at the outskirts of the Hermitage area. Rue de l'Hermitage formerly connected with the road to Ennery, a small village 8 kilometers away.

Pissarro's depictions of country lanes typically entice the viewer to follow a curve or bend to a dis-

Return to rue de l'Hermitage and turn left, continuing to just past No. 46.

Continue up rue de l'Hermitage. After you pass sente des Chaudronnières, walk for another 5 minutes, then stop. (If you reach the firing range, *centre de tir*, you've gone too far.) Look to the west for the approximate location

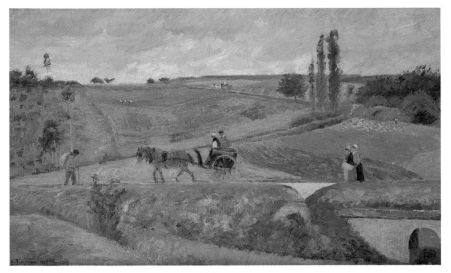

Pissarro, *The Ennery Road near Pontoise*, 1874

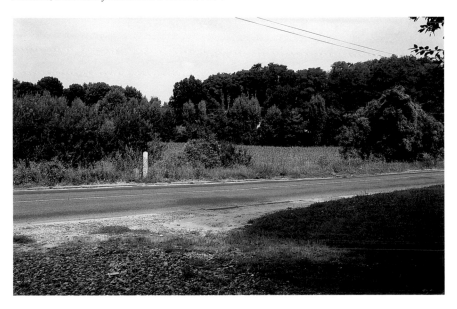

tant point; here the road's horizontal line keeps the viewer at a distance. Fields depicted as angled planes tilt up to the high horizon line, giving the work a distinctly modern feeling despite the old-fashioned cart and the walking peasants.

of *The Ennery Road near Pontoise* (This site is off the map.)

Place du Pont to Musée Pissarro

Return down rue de l'Hermitage to the Oise. Continue right to place du Pont, at the bridge. (See detail map.)

Turn right and right again up the steep, narrow rue de la Roche. At the first street on your extreme left, rue du Château, continue uphill to the Musée Pissarro.

The tree- and flower-filled park outside the Musée Pissarro offers benches and a good place to relax. The panoramic view from here is a fascinating blend of two eras.

From the west side of the park, locate two church domes: Notre-Dame and the larger Saint-Maclou Cathedral. The final area of exploration is near Saint-Maclou and then beyond Notre-Dame to the Château de Marcouville in the hamlet of Les Pâtis. Pissarro painted here in the early to mid 1870s, and Cézanne, then his student, set up his easel in this location at the end of that decade.

Musée Tavet to Rue de Gisors

Turn down the stairs on rue de Paon, and cross place de la Corne to rue de la Chevalerie. Turn right to a large parking area in front of the Hôtel de Ville. Circle to the left to visit the Musée Tavet, or proceed on rue Victor-Hugo to boulevard Jean-Jaurès. Turn left and continue uphill on rue de Gisors to its intersection with rue de la Citadelle.

Leave the park and the Musée Pissarro to proceed to the Musée Tavet and rue de Gisors.

In the nineteenth century, the rue de Gisors connected the fields of the Vexin to the markets of Pontoise. Today the area is crowded and commercial, tremendously changed from Pissarro's time. At the intersection of rue de Gisors and rue de la Citadelle, turn back to see the site of Pissarro's painting **Pontoise, the Road to Gisors in Winter** (1873). Notice the small street, rue Revert, on the right in Pissarro's painting. It will lead you to the next site.

Rue Revert to Sente de l'Auge

Backtrack on rue de Gisors to rue Revert. Turn right, and right again on rue Saint-Jean. Look for 118 *bis* on the right; immediately on the left is sente de l'Auge. (If you reach rue de la Justice, you have gone too far.) Walk down the footpath a few feet.

The elevated view from the sente de l'Auge, a footpath, is my favorite of the entire tour of Pontoise and the Hermitage. Look right to see the river Viosne and the tree-filled grounds of the Château de Marcouville. The blend of old and new is visually exciting. Cézanne painted *The Poplars* (c. 1879–82), a group of lush green trees along the bank of the Viosne, from a position below you.

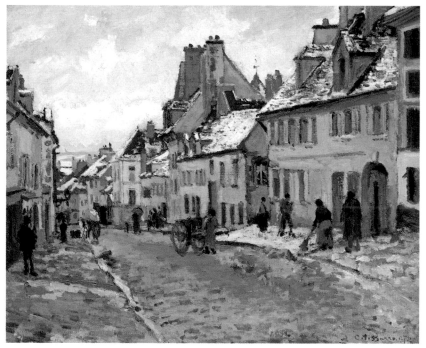

Pissarro, *Pontoise, the Road to Gisors in Winter*, 1873

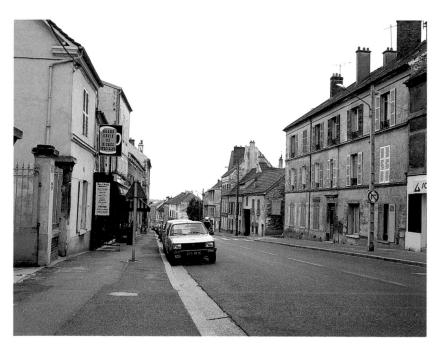

About three-quarters of the way down the sente de l'Auge, an unpaved path, ruelle des Poulies, goes to the left. Unfortunately, this path is completely overgrown, which makes viewing the exact location of Pissarro's *Pontoise* (1872) impossible today.

Rue des Deux-Ponts to Pontoise station

Continue to the bottom of sente de l'Auge and turn right on rue des Étannets. Go just beyond rue des Deux-Ponts, and look toward the south to see a Cézanne site.

Cézanne painted **Mill on the Couleuvre at Pontoise** in about 1881, during his second sojourn in Pontoise. The work demonstrates his interest in depicting inherent structure. The walls and roofs of the mill and surrounding buildings are reduced to simplified planes; space and volume are synthesized by his use of color. (The roof of the mill was recently repaired with funds donated by Friends of French Art, an American group organized to raise money to conserve French art and important historic locations.)

Both Pissarro and Cézanne painted in this area, influencing one another and advancing their art as they interpreted the Pontoise landscape. Pissarro encouraged Cézanne to move his easel outdoors and to lighten his palette. Their styles remained unique, however. Cézanne's landscapes reveal his analytic approach to the structure of his compositions, whereas Pissarro's works always suggest a human environment.

To return to the station, backtrack along rue des Étannets, past sente de l'Auge, until you reach rue de Rouen. Circle right around the church (Notre-Dame) to rue Carnot. Continue straight ahead to place du Général-de-Gaulle and the station.

Overall, Pissarro's rural landscapes stand in contrast to paintings of bourgeois leisure by Monet and Renoir. However different in subject matter, Pissarro's village scenes with thatched cottages, fields, and farmyards were considered equally revolutionary for their direct and unsentimental portrayal of the countryside and its inhabitants.

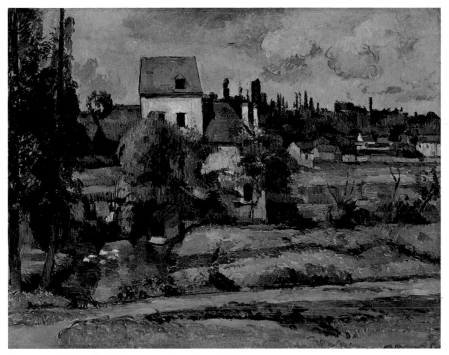

Cézanne, *Mill on the Couleuvre at Pontoise*, c. 1881

ITINERARY

TOUR TIME: about half a day

AUVERS TOURIST OFFICE
Rue de la Sansonne
Tel: 30-26-10-06

FARES
Paris to Pontoise: 36.80 Fr
Pontoise to Auvers: 6 Fr

To go to Auvers, take the train from Gare Saint-Lazare (platforms 8–12) to Pontoise. Buy a round-trip ticket from an automatic ticket machine. Keep the ticket; you will need it to exit the station at Pontoise.

In the Pontoise station, follow the sign to place de la Gare. Here buy a ticket to Auvers-sur-Oise from an automatic ticket machine. Then re-enter the track area and immediately turn left. Board the train on your left, toward Creil, at the most forward end (away from the station).

On arriving at Auvers, check the board inside the station for your return time to Pontoise.

AUVERS-SUR-OISE TOUR

The small, semirural community of Auvers-sur-Oise, north of Paris, retains a nineteenth-century atmosphere. It is the location of van Gogh's grave and the Inn Ravoux, now named Maison de van Gogh, where the artist died in 1890.

The Auvers tourist office sells a map (which locates additional painters' sites) and a walking-tour in English, but I found some of the information unclear. This office also has a large selection of art books, postcards, and prints for sale. In the same building is a small art gallery, the Musée Daubigny. Its hours are irregular; phone the Auvers tourist office to inquire when it is open.

Although the station at Pontoise is small, you might encounter difficulty finding the train going on to Auvers. From Paris it is important to ride in a forward car, as the rearmost ones are sometimes disconnected at Pontoise. The ride to Auvers takes less than 15 minutes. The flowers, architecture, and country atmosphere make it a scenic journey.

A last note: if you are an artist, take a sketch pad. Auvers-sur-Oise is charming and uncrowded; you could set up an easel behind or near the church, in the public park, or even in the town square. There are also many interesting places to sketch off the main road. The light is bright, and the myriad houses, flowers, and vegetable gardens will hold your interest.

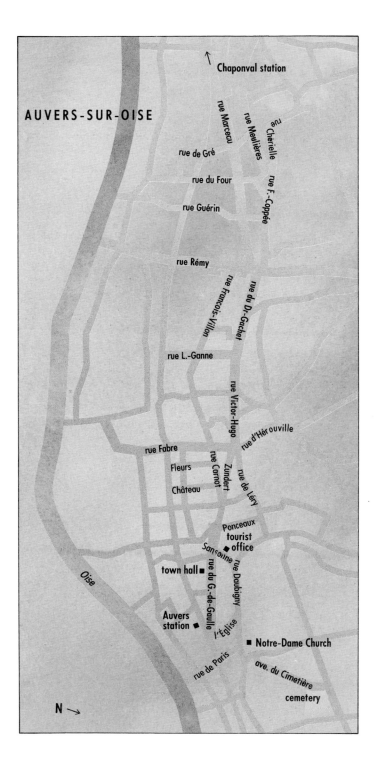

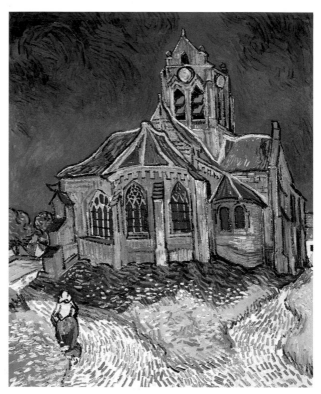

Van Gogh, *The Church at Auvers-sur-Oise*, 1890

Auvers station to Notre-Dame Church

Exit the station, cross the major street, rue du Général-de-Gaulle, and turn right. Follow this road to the traffic light at rue de Paris and turn left. Continue uphill, taking the fork to the right at the bust of Daubigny. Almost immediately the site of van Gogh's *The Church at Auvers-sur-Oise* will be on your left.

Van Gogh took the village church at Auvers as the subject of one of his final masterpieces, **The Church at Auvers-sur-Oise** (1890). If you are at the church in mid-afternoon in summer, you can observe its shadow in the same position as the artist did.

In the painting, in the orange shadow and the varied blues of the church walls, you can see that van Gogh's sumptuous colors and fluid lines are not the reality of the building and the road before it. With astonishing effect, his exaggerated colors flood the canvas with an emotional sensibility that transcends the actual scene.

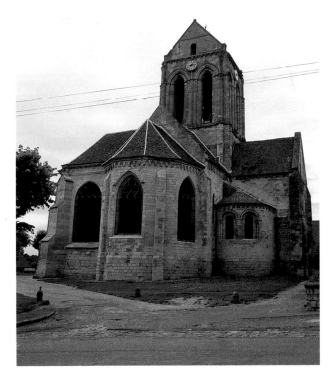

At first one does not see the greens, blues, yellows, and browns that van Gogh painted while standing on the dusty path before the old, drab church. But the colors and movement that van Gogh saw in his subject, and wanted us to see as well, come to life as one waits and observes.

Before you leave the church area, notice the view toward the railroad station. It is similar to that pictured in van Gogh's *View of Auvers* (1890) and gives an opportunity to appreciate the abundant greenery from which a number of red-orange roofs emerge.

Notre-Dame Church to Auvers cemetery

Leaving the church, continue uphill on the main road. Go right on avenue du Cimetière. Enter the cemetery and immediately turn left. Follow the path that parallels the outer wall, and halfway around the back wall you will find the graves of Vincent and Theo van Gogh.

The wheat field, scene of the next painting, lies between the church and cemetery.

Van Gogh and his brother Theo are buried side by side in the village cemetery, in an ivy-covered grave. Always Vincent's ardent financial and emotional supporter, Theo perhaps could not survive the loss of his creative brother. He died just six months after Vincent.

Your next stop is the nearby tranquil field where van Gogh painted **Crows over the Wheat Field** (1890), under a peaceful, pale blue July sky. (His viewpoint was from mid-field, with the church at his back, the cemetery at his right.) Looking at a reproduction of the painting, you will see at once that van Gogh was communicating a very different feeling: his sky is turbulent, the fields appear chaotic, and the birds seem to fly aggressively toward the viewer. Although it has never been established that this was van Gogh's final painting, as some art historians believe, it certainly could represent his mood during his last days.

Another painting, *Wheat Field under Clouded Sky* (1890), also done during this time, is more optimistic. It has the same troubled sky as *Crows over the Wheat Field*, but the mood is calmer. In a letter to his brother, he mentions these two paintings and refers to "the health and restorative forces that I see in the country." Unfortunately, that was not enough; it was in these fields behind the church that van Gogh shot himself in late July 1890.

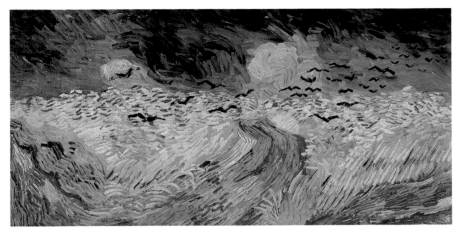

Van Gogh, *Crows over the Wheat Field*, 1890

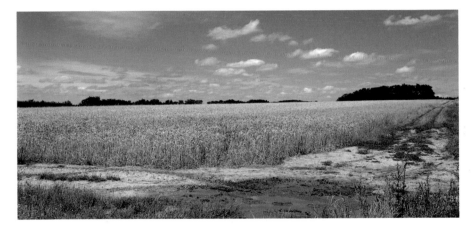

Van Gogh, *Landscape with the Château of Auvers at Sunset*, 1890

Backtrack to the church. Behind it, to the left, take the stone steps down to rue Daubigny. At the bottom, turn right, and immediately on your left, take either path to the main street below, rue du Général-de-Gaulle. There turn right. Travel on the left side of the street and look to the right, over the tall stone wall, to see the site of van Gogh's paintings of Daubigny's garden.

Rue Daubigny to Rue de Zundert

Barbizon painter Charles-François Daubigny moved to Auvers in 1861 to a house and studio in the center of town. Shortly before his death he acquired a second house, located near the church and railroad station. Van Gogh painted two views of its garden in 1890: *Daubigny's Garden* and *A Corner in Daubigny's Garden*. Metal placards with color photographs of the paintings on either side of the garden will help to orient you to the site. To the left of Daubigny's garden is a park featuring a sculpture of van Gogh by the twentieth-century artist Ossip Zadkine.

Up on the hill is the Château de Léry and the site of van Gogh's **Landscape with the Château of Auvers at Sunset** (1890). The painting was done from a location farther from where you are standing, but this spot is a convenient place from which to view the château.

Rapidly executed with bold expressive brushstrokes, this beautiful painting is typical of van Gogh's Auvers style. Most of the domestic buildings he painted in Auvers were peasants' thatched-roof cottages, often clustered together to emphasize their interdependence. In contrast, the château is depicted isolated on the hill, with no one in sight.

For a view of the château, continue past the *mairie* (town hall), on the left, and Maison de van Gogh (Inn Ravoux). (Turn right at the first street, rue de la Sansonne, to visit the tourist office and the site of van Gogh's *Village Street and Stairs with Figures*, 1890.)

Walk to where rue de Zundert branches to the right and rue Carnot to the left. To get the best vantage, travel along rue Carnot for just a moment, and look uphill at the château.

Rue du Dr-Gachet

Continue on rue Carnot and turn right on rue Fabre. Go left on rue Victor-Hugo, the first street. Eventually this street name changes to rue du Dr-Gachet (it is not marked). Continue to No. 78, the doctor's home (about a 10-minute walk from the château).

The site of Cézanne's *Crossroad of the Rue Rémy, Auvers* is at the end of rue du Dr-Gachet.

For forty years Dr. Gachet's house and gardens were a gathering place for artists. (It is now a private residence.) The gardens have vastly changed since van Gogh painted *Dr. Gachet's Garden at Auvers-sur-Oise* (1890) and *Mlle. Gachet in Her Garden at Auvers-sur-Oise* (1890). In Gachet's time, chickens, ducks, pheasants, goats, rabbits, dogs, and cats roamed the property.

Paul Cézanne, who came to Auvers in 1871, lived near Dr. Gachet and made several paintings in the immediate area. The site of one of these works, **Crossroad of the Rue Rémy, Auvers** (c. 1873), can be found by continuing along rue du Dr-Gachet to its end. Just before you reach the intersection, look straight ahead.

Up to this point in Cézanne's brief career, he had chiefly painted either still-lifes or works with allegorical or historical themes. The Old Masters of the Venetian and Spanish schools had been his major inspiration, black his favorite color. Cézanne knew he needed to enlarge both his vision and his technique and picked Pissarro, the oldest and kindest of his contemporaries, with whom to study.

As you look across rue Rémy, you might consider Cézanne's rendition of this site dreary, foreboding, and dull, but for Cézanne it represented a departure from his old painting style. In this work he used some brighter hues and borrowed Pissarro's subject matter of a country road and houses. Notably absent are Pissarro's humble country folk, but Cézanne was, above all, interested in representing solid structure within a dynamic composition.

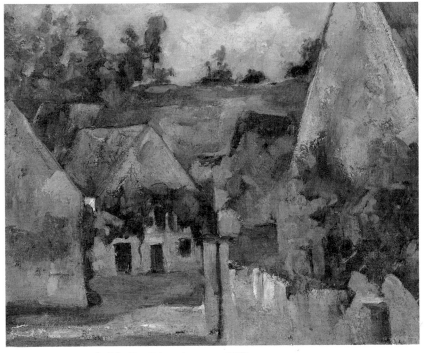

Cézanne, *Crossroad of the Rue Rémy, Auvers*, c. 1873

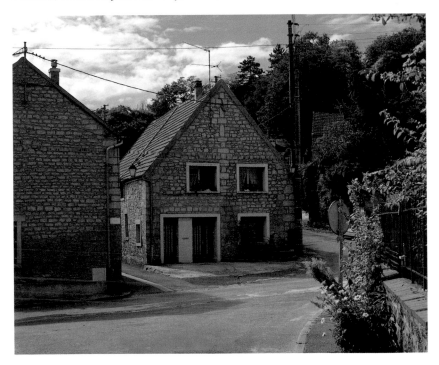

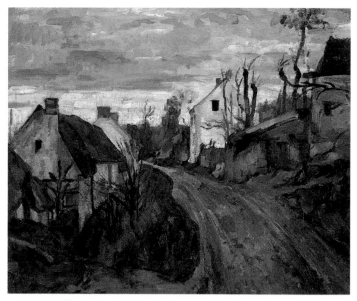

Cézanne, *Village Road, Auvers,* c. 1872–73

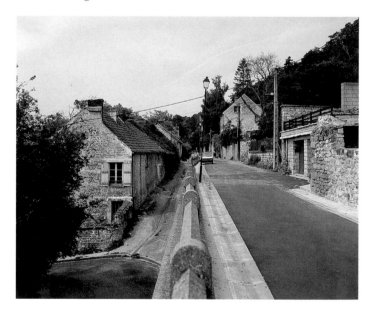

Rue François-Coppée to Rue Chérielle

From the corner of rue Rémy and rue François-Coppée to the site of Cézanne's **Village Road, Auvers** (c. 1872–73) is only a short walk. Altering the perspective of the actual site to suit his composition, Cézanne again painted a country road, a simple motif that is made significant by the artist's masterful interpretation. He used pure color, and the sky is light, but the painting remains subdued. The artist had not yet adopted the light, airy Impressionist style.

Cross rue Rémy and, slightly to the right, go uphill along rue François-Coppée to find several more Cézanne sites. The first, *Village Road, Auvers*, is located just before the intersection at rue Guérin.

From your vantage on rue François-Coppée, you will see only the top of the roof and a bit of white, but it is unmistakably Cézanne's painting site for **Dr. Gachet's House at Auvers** (c. 1873). There are now many more houses, yet the roof lines and curve of the road still resemble those in Cézanne's painting.

Continue up rue François-Coppée, stopping shortly after rue Guérin. Turn around and look back toward Dr. Gachet's house.

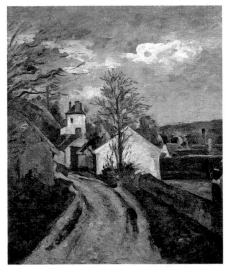 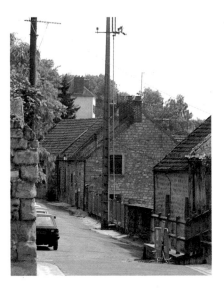

Cézanne, *Dr. Gachet's House at Auvers*, c. 1873

To view the last site, continue on rue François-Coppée, keeping to the right. When you reach rue Chérielle, immediately turn around to look down at the site of Cézanne's *The House of the Hanged Man*.

To reach the train station, take rue Meulières to the first street, rue de Gré, and turn left. Continue to rue Marceau, at the border of Auvers-sur-Oise and Chaponval. Turn right and walk about 5 minutes to the Chaponval station on the left.

From Chaponval, take the train to Pontoise; from Pontoise, return to Paris to Gare Saint-Lazare.

(To return to the Auvers train station is a 45-minute walk.)

The House of the Hanged Man, Auvers-sur-Oise (1873), probably the best known of Cézanne's Auvers paintings, was included in the first Impressionist exhibition in 1874. The painting clearly shows the direction Cézanne continued to pursue throughout his career. Color enhances solid forms, and light is used to create density and depth. Brushstrokes are shorter and broken. Composition is still of ultimate importance, but natural and man-made objects appear integrated. Unfortunately, Cézanne's paintings of this period were not well received, and he decided to leave Auvers and Paris to paint in isolation in his homeland in Provence.

Rue Meulières to Chaponval station

Before walking back to the main road, you might want to explore Auvers a little on your own. Walk to No. 4, rue Meulières, and look up to the right to see an unusual roundhouse designed by Hector Guimard, who designed several Art Nouveau cast-iron entrances for the Paris Métro between 1898 and 1901.

From Pontoise you can choose a train to Gare du Nord; you might enjoy different scenery returning to Paris. Look for platform 1, directly opposite the train from Auvers. If you bought a round-trip ticket to Pontoise from Paris, take platform 2 (through the subterranean passageway) to Gare Saint-Lazare. (The price is the same, and both trains run often.)

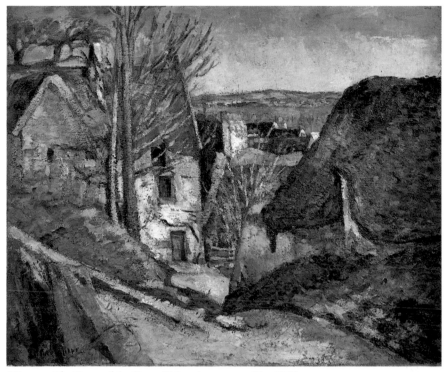

Cézanne, *The House of the Hanged Man, Auvers-sur-Oise*, 1873

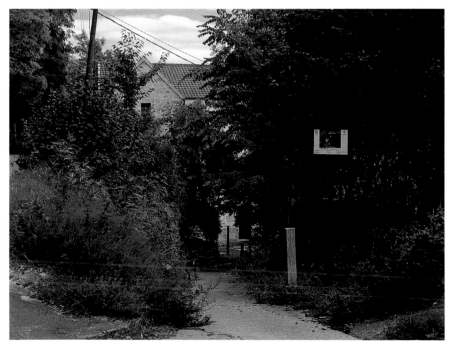

Classic Impressionism

The paintings created at Argenteuil represent the classic phase of Impressionism. Monet lived here for six years (1872–78) and painted at least 170 works. Sisley and Renoir came to Argenteuil to visit and paint with him; the three had met in Paris, argued in various cafes, and painted side by side in the Ile de France. In Argenteuil they worked together, often painting many of the same scenes along the luminous, ever-changing Seine.

By the time Monet arrived in Argenteuil, following his self-exile during the Franco-Prussian War, he was an accomplished Impressionist painter. Here he expanded his use of color and made his brushwork more complex; the overall blending and harmony he achieved paved the way for his later work at Giverny. Monet's earlier works depict scenes literally, without any sense of editorial comment. In Argenteuil, Monet eventually became highly selective about what parts of scenes, views, and incidents he wished to include, omitting others.

Sisley was the first to join Monet at Argenteuil. In 1872, he and Monet painted at rue de la Chaussée (the oldest street in the town, now known as rue 8-Mai-1945), boulevard Héloise (the grandest and longest street), and also at the highway bridge, the Pont d'Argenteuil.

The next artist attracted to Argenteuil was Renoir. Visiting Monet in 1873 and again in 1874, he too painted with his friend. They both documented the gaiety on the banks of the Seine, as they had done in Bougival. Renoir's Argenteuil paintings are notable for their softer and more feathered brushwork.

Édouard Manet ostensibly went to Argenteuil in 1874 to attend an internationally famed regatta; while there, he made several outdoor paintings.

The most famous is of Monet in his floating studio, done in Monet's style. In his Argenteuil paintings, Manet lightened his palette and explored the diffuse quality of outdoor light. He did not totally endorse the Impressionist plein air method, preferring to use black and earth tones and normally completing his work in his studio. But he did experiment in this direction; art historians believe Monet's presence in Argenteuil persuaded Manet to paint outdoors with the younger painters.

Berthe Morisot, Manet's sister-in-law and a respected member of the Impressionist group, probably also influenced Manet's decision, although she herself never set up her easel with her fellow-painters. Already the subject of two of his paintings (*The Balcony*, 1868–69, and *Berthe Morisot with a Fan*, 1872), Morisot maintained a frequent and lively dialogue with Manet. A superb example of Morisot's landscape painting during this time, *Cornfield* (1874), was done across the river at Gennevilliers.

A great friend to these Impressionist artists was Gustave Caillebotte. Professionally trained as a maritime engineer, this then-beginning painter gave emotional and financial support to the artists working in Argenteuil. He never painted with them, but his Argenteuil works, done over a decade later, reflect their influence. The fragmented splashes of color in Caillebotte's Argenteuil canvases are a departure from his earlier, more structured painting style.

Argenteuil holds a special significance in the history of Impressionism. Here Monet, Sisley, and Renoir painted together for the last time; here they continued to influence each other's creations. The next decade would see the dissolution of the Impressionist group spirit.

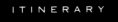

ITINERARY

TOUR TIME: half a day

There is no tourist office in
Argenteuil.

FARES
Paris-Argenteuil: 15.20 Fr

To go to Argenteuil, take one of
the frequent commuter service
trains from the Gare Saint-Lazare,
departing from platforms 8–12.
Buy your ticket from an automatic
ticket machine. The trip takes
about 15 minutes. Sit on the left
for the best view of Argenteuil as
you approach.

ARGENTEUIL TOUR

Argenteuil today bears little resemblance to the
scenes painted by Monet, Renoir, Sisley, Manet,
Morisot, and Caillebotte. Now the city is a
crowded, semi-industrial suburb. But in 1851, the
town administrators worked to promote this small
community as a resort area for Parisians. Argen-
teuil's location on the Seine proved a perfect
recreational boating spot and a convenient com-
mercial port close to Paris. In Monet's time, the
waters were crowded with pleasure craft and com-
mercial boats. Picnickers relaxed on the water's
edge, and strollers wore their Sunday best on the
promenade. Yet Argenteuil was a far more industrial
town than the Impressionist artists usually chose
to portray. Many of their sun-drenched canvases
ignore the reality of its commerce and the pollution
already present, as the artists concentrated on the
river, the light, and the activities of holiday-makers.

Modern Argenteuil no longer enjoys its former
reputation as a resort area. Nonetheless, the natural
beauty of the Seine remains, and the experience of
seeing a location often intentionally represented
only in its light-hearted aspects is worth the visit.

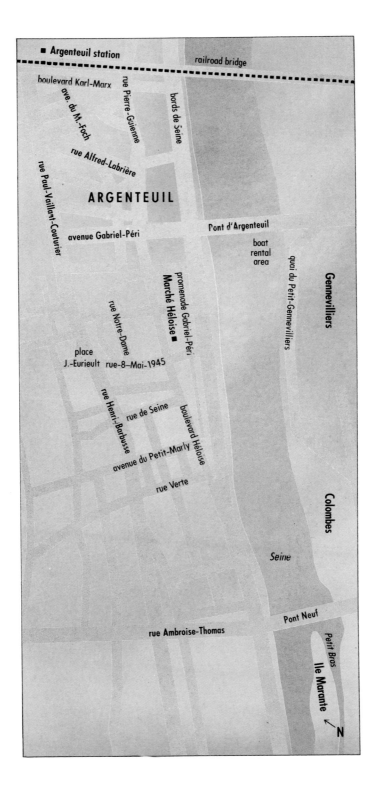

■ Argenteuil station railroad bridge

boulevard Karl-Marx

rue Pierre-Guienne

ave. du M.-Foch

bords de Seine

rue Alfred-Labrière

rue Paul-Vaillant-Couturier

ARGENTEUIL

avenue Gabriel-Péri Pont d'Argenteuil

boat
rental
area

quai du Petit-Gennevilliers

Gennevilliers

promenade Gabriel-Péri
Marché Héloise ■

rue Notre-Dame

place
J.-Eurieult rue-8-Mai-1945

rue Henri-Barbusse

rue de Seine

boulevard Héloise

avenue du Petit-Marly

rue Verte

Colombes

Seine

Pont Neuf

rue Ambroise-Thomas

Petit Bras

Ile Marante

↙
N

In the Argenteuil station: if underground, follow the sign to boulevard Karl-Marx and turn left. At street level, exit the main door, turn right, and then left onto boulevard Karl-Marx (it runs parallel to the station). Continue on boulevard Karl-Marx to rue Pierre-Guienne, the second street.

Continue on boulevard Karl-Marx to the major highway bordering the Seine. Cross the highway and proceed left on the grassy path between the road and the Seine to just past the railroad bridge. This is the site of Monet's *The Railroad Bridge at Argenteuil*.

Backtrack along the Seine to the highway bridge (Pont d'Argenteuil). Climb the stairs, and proceed across to the bridge's mid-point. Look downstream (southwest) toward the former boat rental area.

Argenteuil station to Seine footpath

When Monet lived in Argenteuil, boulevard Karl-Marx was named boulevard Saint-Denis. He rented two homes on this street: the first stood on the corner of boulevard Saint-Denis and rue Pierre-Guienne; the second was at No. 5 (the houses are gone today). From this location Monet could easily travel to his preferred site in Argenteuil, the riverbank of the Seine, just a few blocks away.

Although attracted to Argenteuil for its position on the river and its sailing, Monet did not always attempt to disguise the town's urbanization. Instead he used its smokestacks and bridges as compositional elements, describing them with his brush as he might a tree or the sail of a boat. In **The Railroad Bridge at Argenteuil** (1874), one of several paintings he made of the subject, the hard line of the bridge sharply recedes, and the smoke and rail activity is obvious, but these industrial elements are counterposed by a single boat gliding along the water and a brushy patch of shrubbery on the near bank.

Of the many paintings Monet made in Argenteuil, by far the largest number describe the boat rental area near the highway bridge and the waters surrounding the Ile Marante. He painted numerous canvases from his boat, ingeniously adapted to be a floating studio. Among them are *Boats and Regatta at Argenteuil* (1874), *Red Boats II* (1875), and **Sailboats on the Seine** (1874). (*Monet Painting in His Studio Boat*, 1874, one of Manet's few plein air landscapes, shares the same general view as *Sailboats on the Seine*.)

In these works, as in many of Monet's recreational subjects and riverscapes, commercial activity, congestion, and noise are removed. An

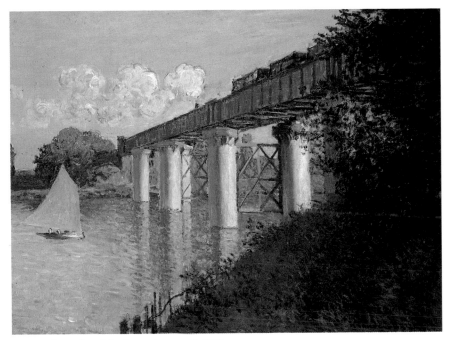

Monet, *The Railroad Bridge at Argenteuil*, 1874

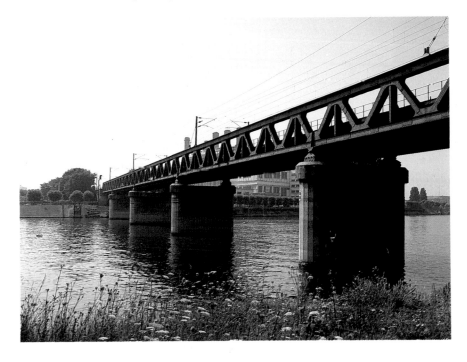

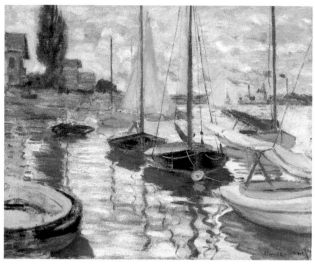

Monet, *Sailboats on the Seine*, 1874

often equal division of reflective water and sky enhances a feeling of harmony. *Sailboats on the Seine* is particularly dazzling; it illustrates Monet's heightened investigation of color. He carefully balanced the red-orange of the houses and boat masts with the complementary blue of the sky, and he used white to create an overall shimmering effect.

Pont d'Argenteuil to Gennevilliers

The Gennevilliers side of the Seine was a popular painting location for Monet as well as his friends. Manet, Sisley, Renoir, and Caillebotte all painted along this bank.

Monet painted several canvases from this vantage point to just the downstream side of the highway bridge. In **The Bridge at Argenteuil** (1874), he contrasted the flickering texture of foliage and water, emphasized by dabs of pure color, with the more solid forms of the bridge and boats. Pink and white clouds lazily drift through the vibrant blue sky. Unfortunately you cannot today walk to the water's edge, as Monet did, and the bridge house and home on the opposite bank are gone.

Continue over the bridge. Take the street on the right posted "S.N.E.C.M.A." (by the Gennevilliers sign), and proceed to the only building on the right. Look through the metal gate by the driveway back toward the highway bridge.

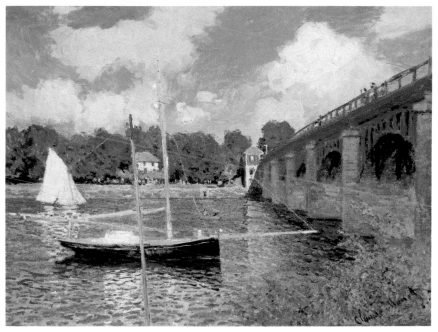

Monet, *The Bridge at Argenteuil*, 1874

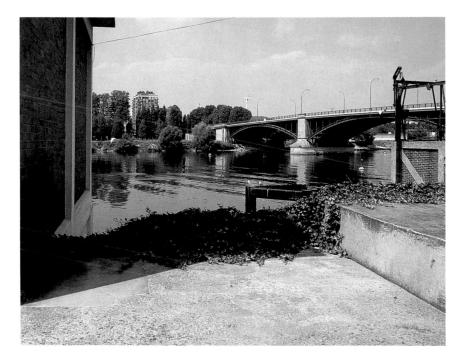

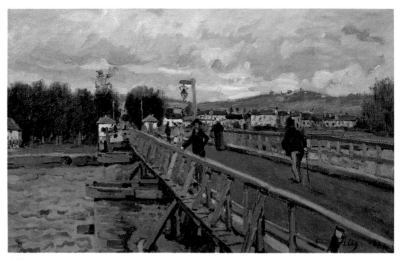

Sisley, *The Footbridge at Argenteuil*, 1872

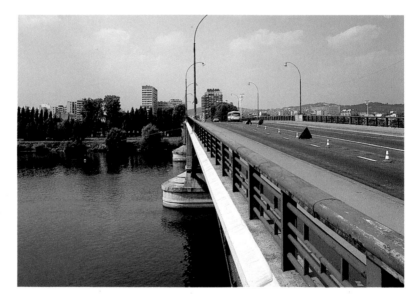

Backtrack to the bridge, turn left, and stop by the concrete slab and metal railing.

Sisley's **The Footbridge at Argenteuil** (1872) was also done from this side of the Seine. Although the bridge has been modernized, the background hills of Argenteuil remain unchanged. His painting shows more human activity than is present in Monet's work of the same period, recalling Sisley's statement, "One of the most interesting qualities in a landscape is life and movement."

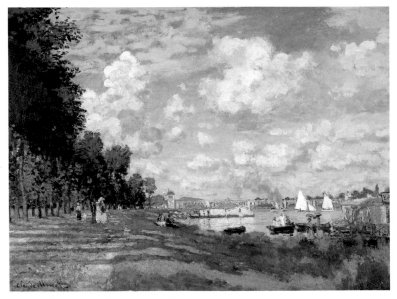

Monet, *The Argenteuil Basin*, c. 1872

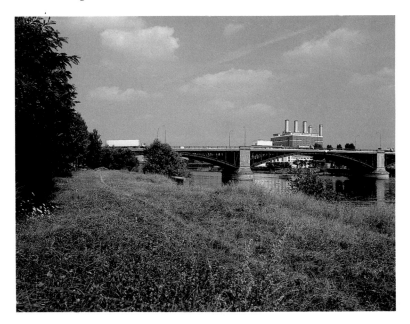

Argenteuil promenade

The panoramic view of Monet's **The Argenteuil Basin** (c. 1872) encompasses the popular riverbank promenade on the Argenteuil side of the

Cross the bridge, descend the metal stairs on the right, pass back under the bridge, and walk

along the water for about 5 minutes. Then turn around and look back toward the bridge.

Seine. With a little imagination, you can envision this area as it was a century ago, when boats occupied much of the water. Monet's painting stresses the pleasures of simple leisure; strollers, picnickers, and boaters go about at their ease under a cloud-filled sky. The long shadows of the afternoon have an abundance of color and a reflective quality, as does the water. Two-thirds of the canvas is devoted to light, cottony clouds; one could almost consider the work a cloud study.

Pont Neuf to Petit Bras

Continue walking about 15 minutes toward the next bridge (Pont Neuf, also known as Pont de Colombes). Carefully cross rue Ambroise-Thomas, ascend the stairs, and cross the bridge. On the other side, descend and approach the water on the downstream side of the bridge.

You are as near as modernization permits to what was, in Monet's time, the beginning of the Petit Bras, a slim arm of the Seine that encircled a small island. None of the painters who favored this site would be disappointed with the present view. Even today the area is relatively tranquil — quite different from the other modern Argenteuil Impressionist locations.

During Monet's first years in the area, this was one of his favorite places to paint. The landscape was still undeveloped and seemingly private, free of the industrial elements of the town. Monet visited the spot often to study the transitory light and seasonal conditions. Here he painted *The Seine at Argenteuil* (1873), *Pleasure Boats* (c. 1873), and **The Seine at Argenteuil, Autumn** (1873). (The latter two works were both done farther downstream.)

Monet's Petit Bras works capture the tranquility and serenity of this less active mooring area. His skillful brushwork and use of complementary color are particularly evident in *The Seine at Argenteuil, Autumn*. True to Impressionist goals, Monet here convincingly represented the fleeting movement of clouds and water.

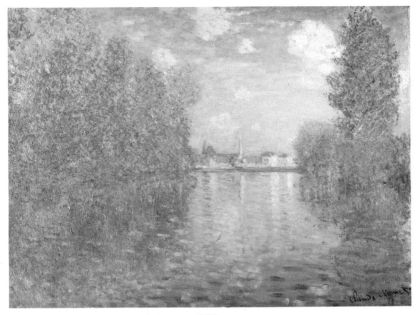

Monet, *The Seine at Argenteuil, Autumn*, 1873

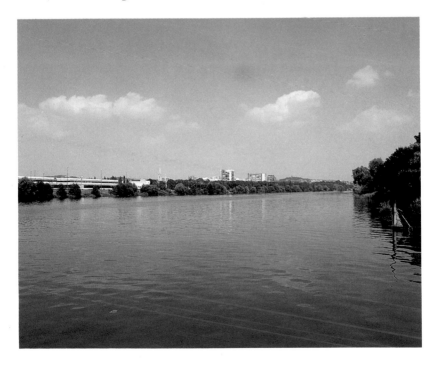

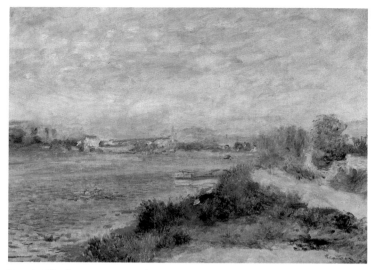

Renoir, *The Seine at Argenteuil*, c. 1873

At this location on the Colombes bank, possibly with Monet, Renoir painted **The Seine at Argenteuil** (c. 1873). He, too, captured the quietness of the area, but unlike Monet, he activated the scene by including two men in a small boat and a larger boat just slipping from sight around a bend in the river. Renoir also painted *Sailboats at Argenteuil* (1874) here, to the right of this site.

Marché Héloise to Argenteuil station

Boulevard Héloise has been a busy thoroughfare for decades. The large outdoor market, Marché Héloise, is open only on Saturdays. You will gain a glimpse of the spirited daily life of the people of Argenteuil if you are there on that day. In 1872 both Monet and Sisley painted on this busy major street and along rue de la Chaussée (now 8-Mai-1945). Both artists were then at an early point in their evolution as Impressionist painters, and these canvases lack the sparkle and color of their more mature works.

Recross the Pont Neuf to the Argenteuil side, descend the stairs, and go right. Where the highway divides (past the second street), veer left on boulevard Héloise and proceed to rue 8-Mai-1945. Continue in the same direction through the paved outdoor market, Marché Héloise.

From the market, backtrack to rue 8-Mai-1945, turn right, and follow the curve of the road to a site painted by Sisley and Monet.

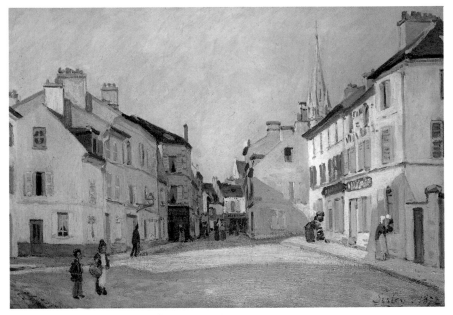

Sisley, *Small Square at Argenteuil (Rue de la Chaussée)*, 1872

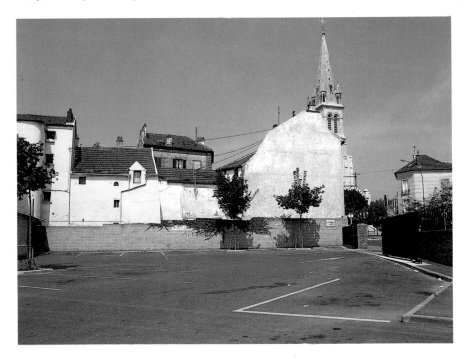

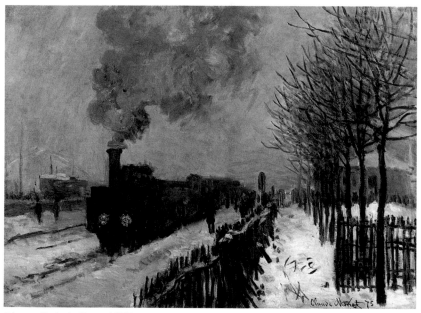

Monet, *Train in Snow*, 1875

Continue along rue 8 Mai-1945 to place Jean-Eurieult, and turn right on rue Paul-Vaillant-Couturier, the main shopping street; part of it is closed to cars. Proceed to the train station to see the last painting site of the tour.

Return to Gare Saint-Lazare via one of the frequent trains.

Monet did several paintings of Argenteuil's two train stations (both since remodeled numerous times). These works demonstrate not only his ongoing interest in the different effects of seasonal change on light but his attempts to incorporate aspects of a rapidly changing industrial world into modern landscape painting. The converging lines of the train track, fence, and trees in **Train in Snow** (1875) focus attention on the steaming train, its speed suggested by its blurred form. The canvas was painted in the approximate area of today's station on boulevard Karl-Marx.

In 1876 Monet returned to Paris to paint, although he maintained his Argenteuil residency. In the following year, he did his well-known train series at Gare Saint-Lazare (from which station he traveled to Argenteuil). In 1878, he permanently left Argenteuil for the more rural Vetheuil. Perhaps he had tired of the encroaching industrialization of Argenteuil, preferring a more tranquil setting. Whatever his reasons, we benefit today from the variety of scenes and activities he depicted during his years in Argenteuil.

Normandy and the Sea

The enthralling beauty and picturesque setting of Normandy provided artists expansive views of the sea, the Seine, and wooded rural areas. Local painters had already gained an appreciation for the light and scenes that changed so strikingly with the weather.

During the 1850s and 1860s, diverse painters from Barbizon, Paris, England, and Holland formed a rebellious clique, which included Narcisse Diaz de la Peña, Constant Troyon, Adolphe-Félix Cals, Daubigny, Courbet, and Corot as well as Boudin, Jongkind, and Monet. They selected a farm in Honfleur, called Saint-Siméon, as the center for their dialogues. They questioned the validity of the Salon, debated the merits of painting in a realistic versus an idealistic mode, and endlessly discussed the issue of finish: how complete is complete?

The Saint-Siméon painters worked and lived together as a friendly yet competitive group. This esprit de corps greatly affected the young Claude Monet, who later promoted the same sense of unity to inspire the camaraderie of the newer Impressionist group.

The best-known painter of the early Saint-Siméon group was Louis-Gabriel Isabey (1804–86), recognized as both a maritime and portrait artist. He painted the aristocrats who flocked to the Normandy beach resorts. It was Isabey who introduced Johan Barthold Jongkind (1819–91) and Eugène Boudin (1824–98) to each other and to the Normandy coast. They, in turn, would have a great influence on Monet.

Boudin, a native of Honfleur, had a frame shop in Le Havre. Through his association with Isabey, and with the encouragement of Barbizon painters Millet and Troyon, Boudin developed his talent for portraying glowing skies, sparkling water, and changing atmospheric conditions. Predominantly a self-taught painter, Boudin worked entirely outdoors. He became famous for his depictions of the Normandy beaches.

Encouraged by Courbet, Monet, and the poet Charles Baudelaire, in 1859 Boudin dramatically enlarged his canvases, which then commanded

greater public attention, and he became a major force in the society of painters at Saint-Siméon as well as with the young Impressionists who studied his work. Boudin exhibited in the first Impressionist exhibition in 1874, but after being accepted in 1875 by the Salon, he never again exhibited with the Impressionists.

Jongkind was thoroughly schooled in the techniques of seventeenth-century Dutch landscape painting. He also went to the coast of Normandy, and in Honfleur further developed as a powerful artist. His dramatic skies inspired the painters at Saint-Siméon. Jongkind integrated Barbizon realism with the recording of a fleeting moment, an early hallmark of the fully developed Impressionist style.

Monet, born in Paris, moved to Le Havre in 1845 at the age of five. His study of boats and water, motifs that gave him continuing inspiration, began on the Normandy coast. By his mid-teens, he had achieved local notoriety as a caricature artist. By 1858 Monet's works were being exhibited next to Boudin's in a local shop. After much persuasion, Monet agreed to accompany Boudin on an outdoor painting expedition and was instantly captivated by watching the older artist paint, patiently building form through the application of color. Monet's career underwent a tremendous change through the experience of that one eventful afternoon. The two continued to paint together in the open air through the early 1860s.

In 1862 Monet met Jongkind, whose influence on the young artist was everlasting. From him, Monet learned the practice of making numerous paintings of one site at different times and seasons, leading to his habit of painting the same subject in series.

The early painters who gathered at Saint-Siméon paved the way for the great Impressionist artists who followed. Though their visits extended over many years, eventually every major Impressionist landscape painter was drawn to Normandy.

ITINERARY

TOUR TIME: one day

TROUVILLE TOURIST OFFICE
32, boulevard Fernand-Moureaux
Tel: 31-88-36-19

HONFLEUR TOURIST OFFICE
33, cours des Fossés
Tel: 31-89-23-30

MUSÉE EUGÈNE BOUDIN
Rue Albert-1er
Hours: 10 a.m.–noon, 2–6 p.m.,
closed Tues., Easter to Sept. 30
(except major holidays); other
times: Mon.–Fri., 2–6 p.m., Sat.–
Sun., 10 a.m.–noon

FARES
Paris to Deauville-Trouville: 236 Fr
Trouville to Honfleur: 16 Fr

Before leaving Paris from Gare
Saint-Lazare, check the train
schedule, which varies greatly
with day, date, and season. There
is usually only one morning train
to Deauville-Trouville (around 8
a.m.), but on Sundays during the
summer, there is more flexibility
for the return to Paris.

If you arrive at the station of
the subway, follow signs to
S.N.C.F. Take the train from plat-
forms 21–25, after buying your
ticket at a window marked
"Grandes Lignes Billets." The trip
is approximately 2 hours.

TROUVILLE AND HONFLEUR TOUR

Honfleur is a wonderfully charming old fishing village and modern-day artists' colony. The town preserves in its original state a fifteenth-century wood and slate church and detached bell tower, the latter painted by Boudin, Monet, and Jongkind. Honfleur also has an abundance of well-preserved sixteenth- and seventeenth-century structures and new art galleries. The Musée Eugène Boudin exhibits Impressionist oils and pastels rarely reproduced in art books, while many local galleries display contemporary art.

Trouville's expansive beach was painted by Boudin, and the Hôtel des Roches Noires was immortalized by Monet.

Nearby Deauville, the most elite section of Normandy, is the northern location of high-fashion boutiques. Both Trouville and Deauville have casinos.

If you wish to experience Impressionist history firsthand, spend a night at the Ferme Saint-Siméon in Honfleur where these artists congregated. Reservations are imperative, as it is now a luxury hotel (tel. 31-89-23-61).

When you arrive at the Deauville-Trouville station, at the window marked "Reservation," obtain a bus schedule for line 20 connecting Trouville and Honfleur. If none is available, get one at the Trouville tourist office. Before leaving the station, note the departure times of the bus from the Trouville Église stop to Honfleur's Gare routière arrivée stop; it is important to know when this bus runs.

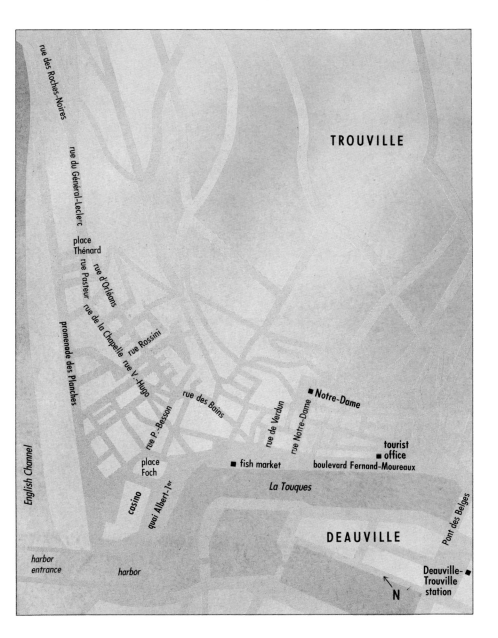

rue des Roches-Noires

rue du Général-Leclerc

place
Thénard

rue d'Orléans

rue Pasteur

rue de la Chapelle

promenade des Planches

rue Rossini

rue V.-Hugo

rue P.-Besson

rue des Bains

TROUVILLE

rue de Verdun

rue Notre-Dame

■ Notre-Dame

tourist
■ office
boulevard Fernand-Moureaux

■ fish market

place
Foch

casino

quai Albert-1er

La Touques

English Channel

DEAUVILLE

Pont des Belges

harbor
entrance

harbor

Deauville- ■
Trouville
station

N

Pont des Belges to Promenade des Planches

Exit the station and make an immediate right turn; cross the Pont des Belges.

The Pont des Belges separates Trouville from Deauville. Walk across slowly, as the view is an appropriate introduction to this resort area.

Turn left and walk along boulevard Fernand-Moureaux for about 5 minutes. Shortly after passing the fish market, veer left on quai Albert-1er and circle halfway around the Trouville casino. Look left to the harbor entrance.

As you walk, notice the large outdoor fish market on the left where Boudin did many paintings and studies between 1888 and 1895. The casino road just past the fish market goes to the harbor.

Although the site of **Entrance to Trouville Harbor** (1886) is now different than it was in Boudin's time, and the two lighthouses have been replaced by a pair of red and green entrance markers, the sky and the water remain as he immortalized them over 100 years ago. Boudin, a native of Honfleur and son of a sea captain, never tired of depicting the activity along the Normandy coast. This small, jewellike painting is typical of his style. Without sacrificing detail, he sketched this airy scene with darting strokes of fresh color.

Continue around the casino and proceed to the wooden boardwalk, the promenade des Planches.

It was on the casino boardwalk that Boudin so often set up his easel and did literally hundreds of canvases depicting middle-class beachgoers. Here Boudin conscientiously painted strollers in full-skirted dresses, elegant hats, and carrying parasols. Boudin staunchly defended his subject as appropriate. He once wrote, "Do not these middle-class men and women walking on the pier . . . have a right to be fixed on canvas?" He painted them with the same care and respect that he had for the sky, clouds, and water.

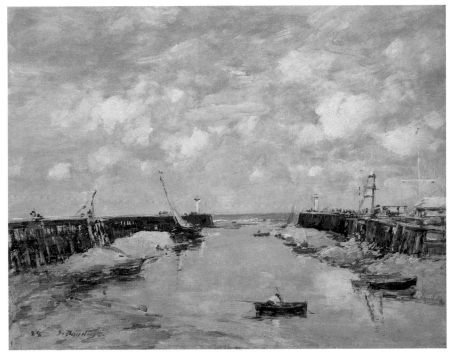

Boudin, *Entrance to Trouville Harbor*, 1886

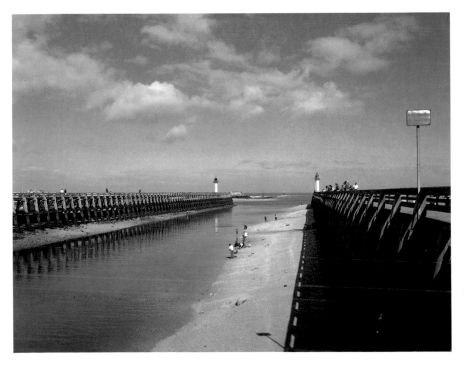

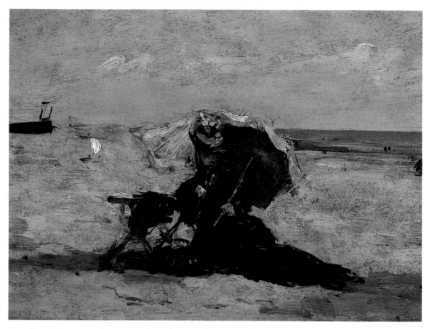

Boudin, *Woman with a Parasol on the Beach at Trouville*, c. 1880

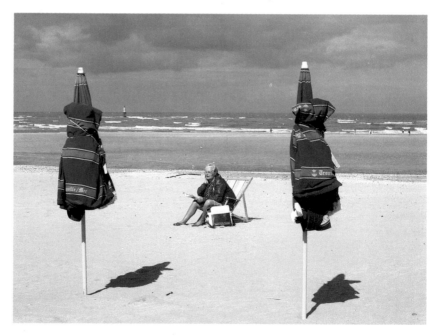

Woman with a Parasol on the Beach at Trouville (c. 1880) is a study of sunlight and lambent sea air heightened by the contrast of the seated woman's sober, dark costume and the almost formal sense of repose that lends her dignity in this light-hearted setting. Boudin's unique contribution to the Impressionist movement was his skill in handling details. He painted women's fashions, boat rigging, and sails with an exact eye.

Boudin always painted directly from life to convey the sparkle and vitality of his subjects. Like the other Impressionists, he was concerned with atmospheric effects and painted in a variety of weather conditions. He used specks of pure color to harmonize and dramatize a loose, impressionistic scene.

Hôtel des Roches Noires to Honfleur bus stop

The promenade continues to the hotel and the site of Monet's **Hôtel des Roches Noires, Trouville** (1870). With the exception of the steps and the sculp-

Continue along the wooden promenade approximately 15 minutes. Near its end, next to a large

Monet, *Hôtel des Roches Noires, Trouville*, 1870

grassy area, look to the right to see the Hôtel des Roches Noires.

After studying this location, walk a little farther on the boardwalk. To the right are steps leading to the main road, rue du Général-Leclerc. Backtrack on it to the right toward the main area of Trouville, or retrace your path along the wooden boardwalk.

When the main street divides at place Thénard, continue left on rue d'Orléans (not marked) to its intersection with rue des Bains. Follow rue des Bains to boulevard Fernand-Moureaux; go left. At rue Notre-Dame, a steep, narrow street, turn left to the bus stop in front of the church. The trip to Honfleur, on line 20, takes about 20 minutes.

ture on top, the old hotel today looks exactly as it does in Monet's painting. Two other Monet works, *The Beach at Trouville* and *Camille Monet at the Beach at Trouville* (both 1870), were painted in front of this hotel. When you walk onto the sand (to the left), you will see that Monet's composition shows a shoreline closer than it presently is. Monet might have altered the scene, as was not unusual among Impressionist painters, or the configuration of the beach might have changed over the past century.

These paintings, all done during the summer of 1870, are representative of Monet's early Impressionist work, with its wispy, loose brushstrokes. He, like Boudin, chronicled the beachgoers on the Normandy coast, interpreting contemporary society in a well-ordered landscape setting.

Monet's sojourn in Trouville was brief. With the surrender of French forces to the Prussians that fall, he fled to England and Holland for fifteen months. He never again painted in Trouville.

Honfleur to Old Harbor

The next stop on your trip is the fishing village of Honfleur, sometimes identified as the "Barbizon of Normandy." Encouraged by the variety and freshness offered by this unpretentious setting, many artists traveled here to paint the area's woods, coast, and towns.

As you ride the bus to Honfleur, sit on the left side. You will see views similar to Boudin's many studies and paintings of skies, fields, and cows, such as **Seven Cows in a Meadow, Stormy Sky** (c. 1881–88).

Boudin, *Seven Cows in a Meadow, Stormy Sky*, c. 1881–88

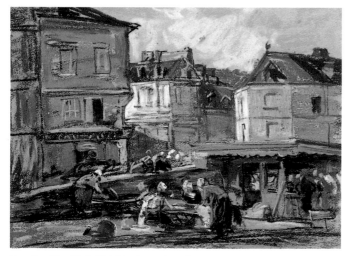

Boudin, *The Little Fish Market at Honfleur*, c. 1859

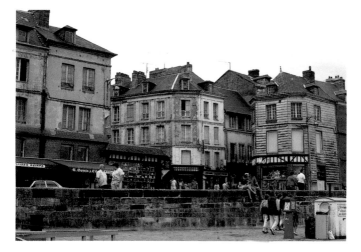

From the tourist office in Honfleur, it is only a short walk to the colorful, boat-filled seventeenth-century harbor. From the top end of the harbor, you can look across to the site of Boudin's **The Little Fish Market at Honfleur** (c. 1859), which remains remarkably faithful to this depiction. Characteristic of the interests of the Saint-Siméon artists, this colorful pastel bears witness, without grandiloquence, to the flurry of dockside activity. Brief strokes of the chalk define the scene's sparkle and life.

At Honfleur, exit the bus on place de la Porte de Rouen, near the tourist office. (If it is open, get a map and list of local art galleries.) Proceed left around the corner onto quai de la Tour; turn left again onto quai de la Quarantaine. Go left when you reach the old harbor, and stop about halfway down the quai. Look to the left to see a Boudin site.

Place Hamelin to Musée Eugène Boudin

Circle around the old harbor on quai Sainte-Catherine; at its end turn immediately left onto rue des Logettes. At the top of this uphill street, turn right into a large square, place Sainte-Catherine.

Ascend from the harbor to the large square that houses the fifteenth-century church of Sainte-Catherine, and to its left, the bell tower. This tower and church were built of timber by shipwrights, who drew not only on boat-building skills and conventions, but also on traditions of timber architecture in France that predate the stone spires of its Gothic cathedrals. Jongkind, Monet, and Boudin all depicted this late fifteenth-century structure: Monet in **Honfleur, the Belfry, Sainte-Catherine** (1867), Boudin in *The Belfry at Sainte-Catherine* (1859), and Jongkind in *Sainte-Catherine, Honfleur* (1864). The bell tower is open to visitors.

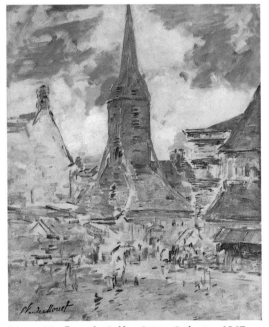

Monet, *Honfleur, the Belfry, Sainte-Catherine*, 1867

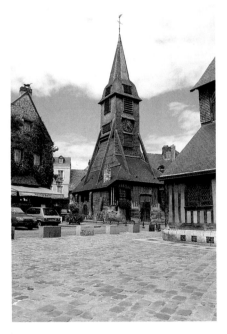

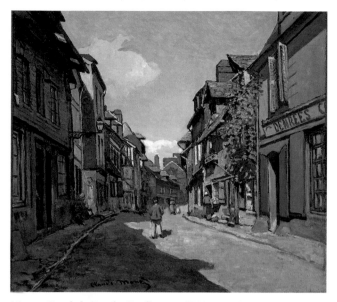

Monet, *Rue de la Bavole, Honfleur*, c. 1864

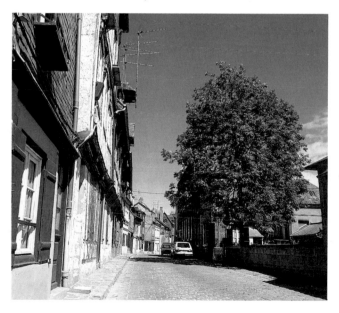

From Sainte-Catherine, the route goes to No. 46, rue de la Bavole. Looking carefully on the left side of the street, you can recognize the same building Monet depicted in **Rue de la Bavole, Honfleur**

Turn back to rue des Logettes and turn right into a little square, place Pierre-Berthelot. Continue to the right on rue Brulée. The name

changes to rue de la Bavole; at No. 46, turn around to view Monet's site for *Rue de la Bavole, Honfleur.*

(c. 1864). He apparently appreciated the charm of these sixteenth-century homes, and used them and the shaded street to explore the effects of sunlight. Fortunately for us, the civic government of Honfleur in 1972 designated the entire historical section of the city as a preservation district. Strict regulations govern renovation, and nothing can be destroyed. Honfleur is one of the most carefully protected historical sites in all France.

Backtrack to place Sainte-Catherine, pass the bell tower, and make a right to rue des Lingots, a downhill street. Turn left onto rue de l'Homme-de-Bois. Continue to rue Albert-1er; turn left to the Musée Eugène Boudin.

Your next stop, the Musée Eugène Boudin, is well worth the visit. It has several good pastels and paintings by Boudin as well as works of Jongkind and Monet which I had not seen reproduced in art books. Other paintings in the museum were done in and around Honfleur by local artists.

Rue Bourdet to Honfleur bus stop

When you exit the museum, go to rue de l'Homme-de-Bois and turn right. You will immediately come to rue Bourdet (not marked) on your left, where Boudin had a studio. Take this narrow, steep downhill road. When you reach the bottom, turn right onto rue Haute. Continue on rue Haute toward the old harbor. Retrace your route to the bus stop.

To return to the central area and bus stop, walk through part of the old city. Many of its structures date from the sixteenth and seventeenth centuries and lie in Honfleur's protected zone.

If you choose to spend more time in Honfleur, you may visit a multitude of art galleries, relax at one of the many outdoor restaurants, or take a 30-minute walk to the côte de Grace, a high cliff overlooking the Seine. The Honfleur artists all painted at this location; the view in their time was inspiring. Its natural beauty is worth the walk, but the lure of old buildings and art galleries is also no small temptation.

ÉTRETAT, SAINTE-ADRESSE, AND LE HAVRE TOUR

The Normandy coast cities of Étretat, Sainte-Adresse, and Le Havre have distinct personalities. Le Havre, France's most important Atlantic port (nearly destroyed during World War II) is an example of modern city planning. The wide boulevards are landscaped, and the grounds of the town hall impressive, yet this newly constructed city and harbor area are visually uninspiring. But the new, well-lit Musée des Beaux-Arts boasts the largest collection of Boudin paintings in the world. Near it are the approximate sites of works by Boudin, Pissarro, and Monet.

Sainte-Adresse is an updated version of its nineteenth-century embodiment. Only 15 minutes north of downtown Le Havre, it offers suburban living and isolation from the more mercantile newer city. Sun lovers and recreational boating enthusiasts find it is still a small resort town born from the beach tourism of Monet's day. Old and new summer homes dot the hills overlooking the English Channel. At Sainte-Adresse, in 1867, Monet depicted his father on a terrace looking toward a seemingly distant Le Havre.

Étretat, a tiny resort, 50 minutes by bus north of Sainte-Adresse, is the most startling of these locations. After seeing Étretat, one cannot question why Isabey, Jongkind, Boudin, Monet, Courbet, Corot, and even Renoir all chose to paint its majestic cliffs and channel waters.

It is well worth spending the entire day to see all locations on this tour. Étretat, which attracted so many painters, is still a popular recreational center. Sainte-Adresse, important in Monet's life, is convenient to explore. Le Havre, although not a major Impressionist location, is worthwhile for the

ITINERARY

TOUR TIME: one day

ÉTRETAT TOURIST OFFICE
Place de la Mairie
Tel: 35-27-05-21

LE HAVRE TOURIST OFFICE
Place de l'Hotel-de-Ville
Tel: 35-21-22-88

MUSÉE DES BEAUX-ARTS,
Le Havre
Hours: 10–11:30 a.m., 2–5:30
p.m.; closed Tues.

FARES
Paris to Le Havre: 236 Fr
Le Havre to Étretat: 28.50 Fr

The best way to make this tour is from Paris to Le Havre for a connection to Étretat, Sainte-Adresse next, and finally Le Havre. (Take a sweater; the Normandy coast is windy.)

There are usually two morning trains from Gare Saint-Lazare to Le Havre. If you arrive at the station from the Métro, follow signs to S.N.C.F. and look for the window marked "Grandes Lignes Billets." Buy a round-trip ticket to Le Havre and board at platforms 21–25.

At Le Havre, do not enter the main terminal, but exit the station through a side door on the left. Directly in front of you is a local bus information booth; ask for a

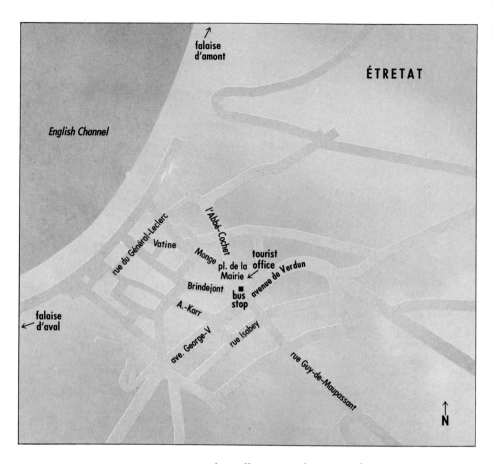

bus map (*plan du réseau*), as you will need it later in the day.

Cross the street to the suburban bus station on the right. The main door is around the back. Check the schedule on the wall for departure times from Étretat to Sainte-Adresse as well as the connection returning to Le Havre.

Take the Fécamp bus to Étretat. Pay the fare on board; the trip takes about 50 minutes.

Boudin collection at the Musée des Beaux-Arts.

To ensure visiting all sites and the museum in one day, your first stop must be the tiny resort town of Étretat. The views of the countryside on the way there are typical of Normandy—lush, cultivated farmland and memorable cows.

Étretat cliffs

In less than a 5-minute walk from the center of Étretat, you can view the monumental cliffs for which the town is famous. To the east, where fishermen still draw their boats up onto the beach, is the site of Boudin's **Cliffs and Yellow Boats at**

The bus stops in Étretat at place de la Mairie, near the tourist office.

Head to your first site by veering down rue Monge. Following

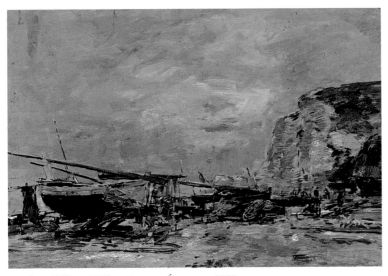

Boudin, *Cliffs and Yellow Boats at Étretat*, c. 1895

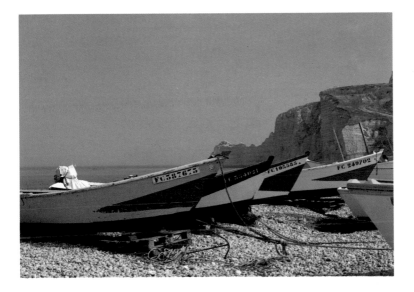

the sign "La Mer," continue straight to the water and a promenade that skirts the beach. As you stand facing the sea, turn right to view the rock formation known as the *falaise d'amont* (eastern cliff).

Look left to view the *falaise d'aval* (western cliff) and *L'Aiguille* (the needle).

Étretat (c. 1895). Boudin evoked a cloudy and dark scene, steadily building the foreground and cliff with short horizontal brushstrokes, a hallmark of his technique.

In 1883, Monet also painted this view in at least three works entitled *Étretat*. All have nearly the same viewpoint and exemplify Monet's habit of painting the same subject in series, studying the effect of time of day and weather conditions on mood and color.

Although Étretat was a thriving beach resort alive with casinos and merrymaking, Monet focused instead on its cliffs, coastline, sky, and sea, emphasizing the fluidity of the water and the solidity of the cliffs.

If you turn to the west, you will see the dramatic lower cliff of Étretat from the same viewpoint as did Boudin, Courbet, Isabey, and Monet.

Boudin's **Cliffs at Étretat** (1890–94) is one of the finest done of this motif. The canvas shows his interest in the way paint is laid down on the surface as well as in the flatness of the picture plane. Equally apparent is his masterful use of color. The dramatic effect of the setting sun is vividly rendered with touches of blue, red, and yellow that accent the gray hues of the cliff.

The view from the top of this formation is spectacular; take the stairs at the end of the promenade to get there. Enjoy this memorable sight as long as time permits before departing for Sainte-Adresse (consult your schedule).

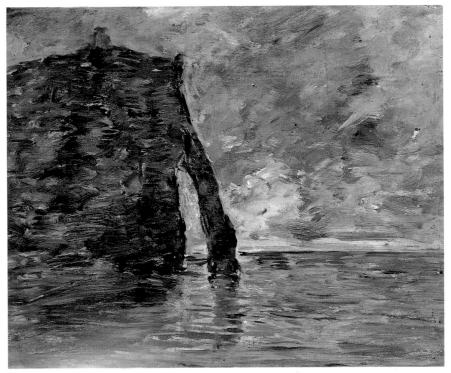

Boudin, *Cliffs at Étretat*, 1890–94

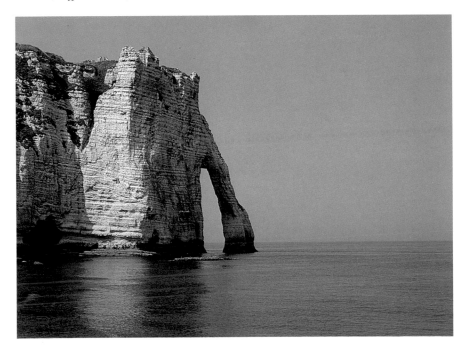

Sainte-Adresse to Rue des Phares

Return to the bus station and board the bus for Sainte-Adresse (a 50-minute trip). Ask the driver to let you off at the Broche à rotir stop. As you leave the bus, walk right and at once go up the hill to rue des Phares. Turn left (downhill) and continue to the first intersecting street, rue Charles-Dalencour. There turn left; immediately on your right is No. 15.

The Sainte-Adresse residence of Monet's cousins, the Lecadres, at No. 15, rue des Phares, was rebuilt around the turn of the century. (The present house bears the sign "Le Coteau.") The gardens Monet painted in *Flowering Garden* (c. 1866) and *Jeanne-Marguerite Lecadre in the Garden* (1866) no longer exist, yet the peace and quiet of Monet's era prevails.

Monet stayed in Sainte-Adresse several times during the summers between 1864 and 1867, for several reasons. He had no money, and here he could stay with his relatives. The Normandy coast provided exciting and challenging subjects for his outdoor paintings. Perhaps most important was the proximity to his artist friends, who had established a stimulating group in nearby Honfleur.

Rue Charles-Dalencour to beach footpath

Continue on rue Charles-Dalencour (the name changes) to its intersection with rue Reine-Elisabeth. Enjoy the short downhill walk on this street to the English Channel. At the first major intersection, place Clemenceau, cross the street and stop at the viewing place left of the shops and restaurants.

During the summer of 1867 Monet reported in a letter to his friend Frédéric Bazille that he had "about twenty canvases on the way." Many were marine scenes featuring local beaches and sailing regattas. Look left (southeast) to spot the church steeple and coastline that appear in **The Beach at Sainte-Adresse**. Although this scene is today crowded with houses and people, the general elements that caught Monet's interest remain: light, water, shore, boats, and beachgoers. In these works one can see the distinctive separate brushstrokes and bits of pure color that Monet relied on to convey the effect of reflecting light. At a time when a mark of finesse in painting was a hard, smooth surface on which individual brushstrokes could not be distinguished, the apparent roughness and unfinished appearance of Monet's canvases attracted some criticism. Today these same features are regarded as his contribution to the Impressionist style.

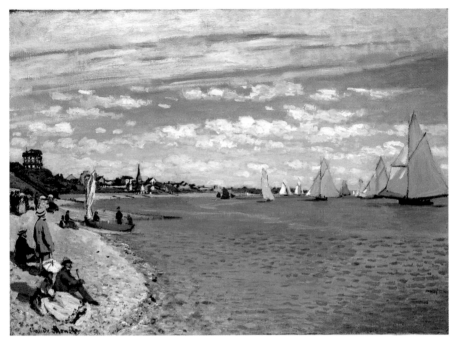

Monet, *The Beach at Sainte-Adresse*, 1867

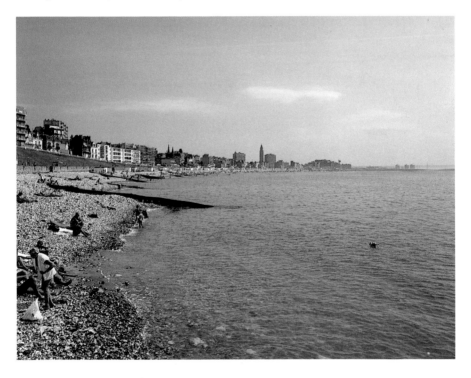

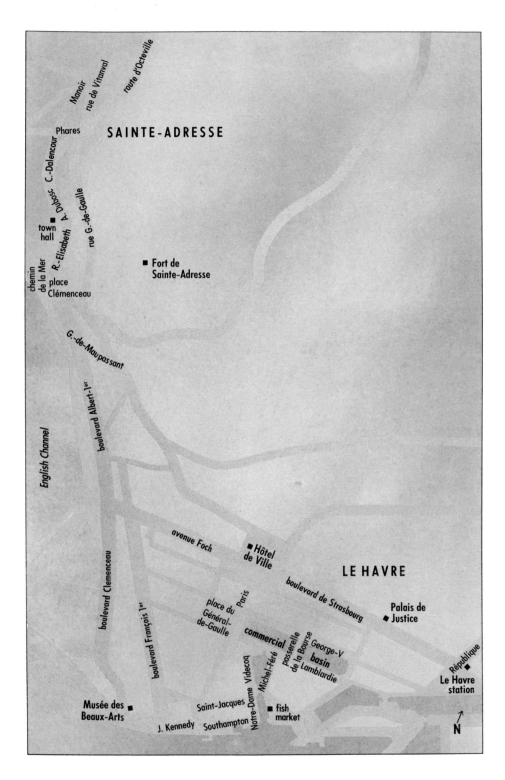

Beach footpath to Musée des Beaux-Arts

Boudin painted **Le Havre Jetty in a Storm** (1895) on a day when the sky was as turbulent as the sea. The seawall, terminating at the two beacons marking the harbor entrance, delineates what there is of horizon. The scumbled clouds, blue sky faintly showing, and agitated water give a convincing glimpse of the passage of a weather front, as the sea is illuminated by a transitory light source.

To reach the beach, travel to the right down the narrow chemin de la Mer; at the bottom turn left and walk the footpath paralleling the beach and water. Continue to the path's convergence with rue Guy-de-Maupassant, the approximate site of Boudin's *Le Havre Jetty in a Storm*.

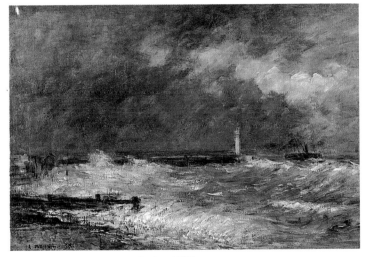

Boudin, *Le Havre Jetty in a Storm*, 1895

At the bus stop on rue Guy-de-Maupassant, you can board the bus to downtown Le Havre (line 1 to the end of line 3, about 15 minutes), or you can walk 20 to 30 minutes along the water on boulevard Albert-1er (the name will change to boulevard Clemenceau) to the Musée des Beaux-Arts.

The Musée des Beaux-Arts, at the end of boulevard Clemenceau, is an architecturally interesting steel, glass, and concrete structure. The breadth of its Boudin collection offers a greater appreciation and understanding of this artist's long career and achievement.

In addition to Boudin's Le Havre paintings, the museum also has two of Pissarro's late works done in this area (their sites are no longer recognizable). There is an exquisite small Daubigny which by itself would make the visit to the museum worthwhile. In addition, there are works by Sisley and Monet.

Quai Southampton to Le Havre station

On leaving the museum, turn left to the quai de Southampton (by the European ferries). Walk along the quai, keeping the water and ships on your right, until it intersects with quai Notre-Dame. Turn left. Walk across the causeway to the right and continue left on quai Michel-Féré. At the commercial basin, cross the footbridge on the right. Turn left and position yourself near the water's edge.

Due to destruction during the war and modern reconstruction, the port of Le Havre bears no resemblance to the early twentieth-century harbor. The precise viewpoint of works created here by Boudin or Monet cannot be pinpointed because of the enormous changes. But you are at the approximate site of several works: Boudin's *The Port of Le Havre* (1888), **Twilight over the Commercial Dock at Le Havre** (1892–94), and Monet's famous *Impression* (1872). All three depict the essence of the Impressionist style, the rapid rendering of the effect of light and atmosphere.

Boudin's *Twilight* was painted twenty years after Monet's *Impression*. The mood of the two works is similar, each tinged with sea mists and the reds of the sun. The view for each is virtually identical, yet one should not conclude that the older Boudin copied the younger Monet. Harbor views, like beach scenes, were one of the most constant themes in Boudin's oeuvre. But his protégé Monet was an innovator, and most think he surpassed his mentor.

Before leaving Le Havre, you may want to spend

Boudin, *Twilight over the Commercial Dock at Le Havre*, 1892–94

time on rue de Paris, the busiest shopping street of the city. To get there, continue along the commercial basin to place du Général-de-Gaulle; turn right on rue de Paris.

To return to Paris, find the bus stop to the right (east) of the Hôtel de Ville and return to the train station. Paris-bound trains depart about every two hours.

TOUR TIME: One-half to one day

ROUEN TOURIST OFFICE
25, place de la Cathédrale
Tel: 35-71-41-77

MUSÉE DES BEAUX-ARTS
Hours: 10 a.m.–noon, 2–6 p.m.;
closed Tues., Wed. a.m.

FARES
Paris to Rouen: 158 Fr

To go to Rouen, take the train
from the Gare Saint-Lazare. Buy a
round-trip ticket at the window
marked "Grandes Lignes Billets"
and board the train at platforms
21–25. Except for Sunday, there
are several trains daily to Rouen.
The trip takes about 55 minutes.

ROUEN TOUR

Seeing Pissarro's and Monet's painting sites is only part of the pleasurable visual and historical experience of visiting Rouen. The scenery on the way to Rouen is reminiscent of many Impressionist landscapes. This busy inland port of Normandy is renowned for its many fine examples of architecture dating from the thirteenth to the twentieth century. The tourist office has literature in several languages to guide you to these architectural points of interest. Rouen is also the city where Jeanne d'Arc was executed in 1431. I recommend visiting this thought-provoking site at the end of your tour.

Situated in a small attractive park, the Rouen Musée des Beaux-Arts has some noteworthy Impressionist paintings and also a comprehensive collection of work by Théodore Gericault, the Rouen-born early Romantic painter. Finally, there is a bustling shopping street, rue Gros-Horloge (closed to automobiles), which boasts lower prices than Paris.

You can easily see the Musee des Beaux-Arts and the painting sites in half a day. I could not resist the shopping, the square dedicated to Jeanne d'Arc, nor the many architectural sites. An entire day in Rouen will allow you to return to Paris with bargain purchases as well as a greater understanding of Pissarro, Monet, and French architecture.

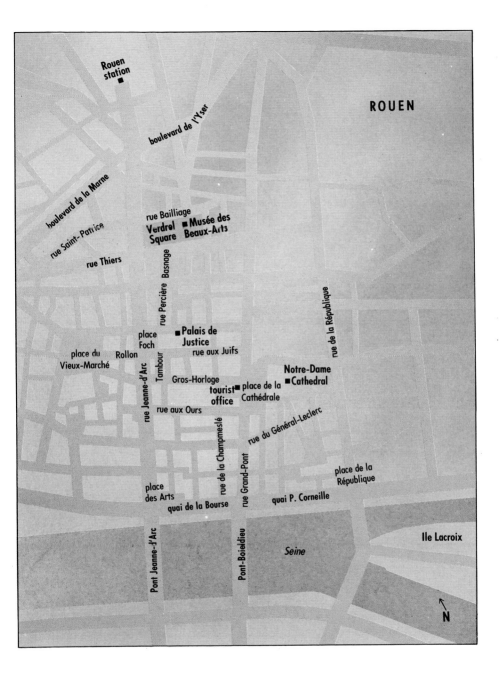

Rouen station to Musée des Beaux-Arts

At the Rouen station, exit the main door and walk straight down the hill on rue Jeanne-d'Arc. In a few minutes, at rue Saint-Patrice on the right and rue Bailliage on the left, you will see Square Verdrel on the left side. Enter through the metal gate (which appears closed) and stroll by the stream around the flower-filled park to the museum.

A pleasant stroll through Square Verdrel brings you to the Musée des Beaux-Arts. There you can see works by Sisley and Monet done in Marly, Moret, and Vetheuil as well as Rouen.

Before leaving the museum, take note of *Bank of the Oise* (1866) by Daubigny. This painting exemplifies the style that influenced the Impressionist painters early in their careers. Monet and Sisley both were affected by Daubigny's sumptuous skies and reflecting water. Compare the size of Daubigny's work and later Impressionist paintings. Daubigny painted large works for patrons of the Paris Salon; his paintings were hung in great homes. The Impressionists were painting for the middle class, and their work hung in small living rooms and studies.

Musée des Beaux-Arts to Notre-Dame Cathedral

On leaving the museum, immediately turn left, leave the park, cross rue Thiers, and walk down rue Basnage and rue Percière, a shopping area. Walk through place Foch and continue on rue Tambour to rue du Gros-Horloge. There turn left and walk to place de la Cathédrale. Before you is Rouen's Notre-Dame Cathedral. To the right is the tourist office. (If you intend to climb the clock tower, stop here to inquire about the times it is open.)

To assume the closest viewpoint to Monet's Cathedral series, stand in front and to the right of the tourist office.

As you walk to the site of Rouen's celebrated cathedral, you will pass another famous sight, the Gros-Horloge. The clock housing spans the street and is decorated in Renaissance style with a golden clock face on either side. (Later on the tour you can visit it.)

Today the cathedral square is a pleasant place to sit and watch people. Notre-Dame, built between 1201 and 1514, is a fine example of Gothic architecture. In 1892, between February and mid-April, Monet painted no fewer than thirty versions of the cathedral, and he worked here again in 1893 (the pictures themselves are dated 1894). Monet's original second-floor location, a few yards from where you are now standing, was destroyed during World War II.

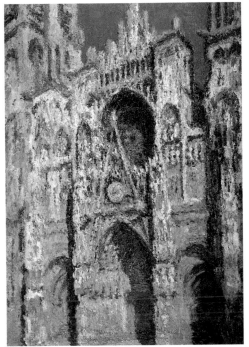

Monet, *Rouen Cathedral, the West Portal and Saint Romain Tower, Full Sunlight, Harmony in Blue and Gold,* 1894

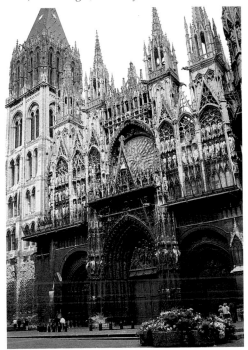

Monet studied the play of light and shadow on the west portal of the church; in the paintings, building details appear to dissolve. These works are studies not of subject or motif, but of nuances of light and weather as hours and seasons passed.

Monet completed the Cathedral series at Giverny; twenty were exhibited at the Durand-Ruel Gallery in 1895. The dramatic effect of displaying twenty paintings of the same subject was not lost on the critics and artists of the day. (Fortunately, five of these works can still be viewed side by side at the Musée d'Orsay in Paris.)

Rue Grand-Pont to Pont-Boieldieu to Quai de la Bourse

To find Pissarro's painting sites, turn from the cathedral facade and walk toward the Seine, on rue Grand-Pont. When you reach the river, continue walking for 1 minute onto the bridge, Pont Boieldieu.

Walk from the cathedral onto the Pont-Boieldieu. Across the water you can see the silhouette of Notre-Dame de Bonsecours, which appears high on the hill in **The Quays at Rouen**, painted by Pissarro in 1883. Looking to the east, you can see Ile Lacroix, where he stood to paint it. Pissarro came to Rouen in the autumn of that year, staying at the place de la République, just a few steps from the river, in a hotel run by his friend Eugène Mürer.

Return to the main street (don't cross), and turn left on quai de la Bourse. Continue along the quai to the trees, and look back to see Pissarro's site of *The Great Bridge at Rouen*.

Pissarro returned to Rouen again in 1886, in the spring and the fall. Troubled now by ill health and poor eyesight, on these occasions he took a room at the Hôtel Angleterre, located on the quai de la Bourse. From his second-floor window, he had an expansive view of the Seine and Saint-Sever, a busy industrial area teeming with factories and warehouses, and from his room he painted several

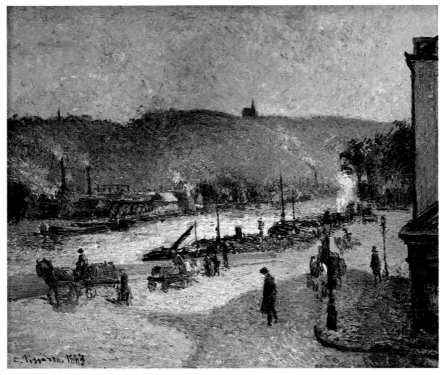

Pissarro, *The Quays at Rouen*, 1883

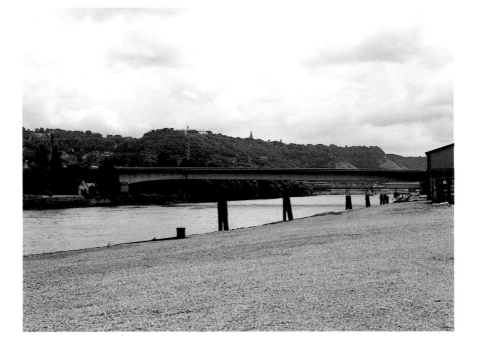

versions of the port's spirited activity. These works, including *Harbor at Rouen, Saint-Sever* and **The Great Bridge at Rouen** (both 1896), are unusual for Pissarro, who usually favored country motifs. Yet they are typical in that they depict workers in their daily environments. Pissarro died in 1903; had he lived longer, he might have become a painter of factory or dock workers, as he was of peasants and farm laborers many years before. Saint-Sever was destroyed during World War II, but the general hustle and bustle of the harbor at Rouen remains as stimulating as it was in Pissarro's time.

Pont Jeanne d'Arc to Place du Vieux-Marché

Advance to rue Jeanne-d'Arc, which continues north from the next bridge, Pont Jeanne-d'Arc.
 Turn right on rue Jeanne-d'Arc and walk to rue Gros-Horloge. Turn left to place du Vieux-Marché.

The place du Vieux-Marché, a few blocks from the river, is significant for its medieval history: here Jeanne d'Arc was burned alive in 1431. Today a dramatic modern church, completed in 1979, commemorates the martyred Joan. Open to tourists, it contains stained-glass windows saved from a sixteenth-century church destroyed during World War II.

From the place du Vieux-Marché, return to rue Jeanne-d'Arc. Proceed across it to visit the Gros-Horloge, or turn left and walk about 20 minutes, slightly uphill, to the train station.

On your way back toward rue Jeanne-d'Arc and the train station, detour to rue du Gros-Horloge and the great clock of Rouen, installed here in 1527. The belfry adjoining it dates from the fourteenth century and may be climbed in spring and summer. The ascent is a worthwhile effort, as the views of the old city from the platform are magnificent.

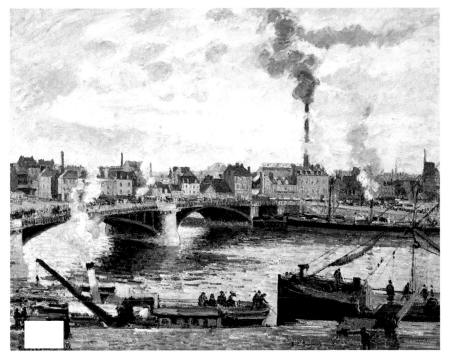

Pissarro, *The Great Bridge at Rouen*, 1896

PAINTING CHECKLIST

All paintings mentioned in the tours throughout this guide are listed below. Page numbers are given for illustrated works, and titles in French are given for those works held by French museums.

EUGÈNE BOUDIN
1824–1898

The Belfry at Sainte-Catherine, 1859
Le clocher à Sainte-Catherine
55 × 43 cm
Musée Eugène Boudin, Honfleur

Cliffs and Yellow Boats at Étretat, c. 1895
Falaises et barques jaunes à Étretat
38 × 55 cm
Collection Musée André Malraux, Le Havre
page 115

Cliffs at Étretat, 1890–94
Falaises à Étretat
38 × 47 cm
Collection Musée André Malraux, Le Havre
page 117

Entrance to Trouville Harbor, 1886
32.4 × 41 cm
Reproduced by courtesy of the Trustees, The National Gallery, London
page 103

Le Havre Jetty in a Storm, 1895
Entrée des jetées du Havre par gros temps
51 × 75 cm
Collection Musée André Malraux, Le Havre
page 121

The Little Fish Market at Honfleur, c. 1859
Petite Poissonnerie à Honfleur
22 × 30 cm
Musée Eugène Boudin, Honfleur
page 109

The Port of Le Havre, 1888
Le port du Havre
32 × 41 cm
Musée d'Orsay, Paris

Seven Cows in a Meadow, Stormy Sky, c. 1881–88
Sept vaches dans un pré, ciel orageux
30.5 × 46 cm
Collection Musée André Malraux, Le Havre
page 107

Twilight over the Commercial Dock at Le Havre, 1892–94
Crépuscule sur le bassin de commerce au Havre
40 × 55 cm
Collection Musée André Malraux, Le Havre
page 123

Woman with a Parasol on the Beach at Trouville, c. 1880
Femme à l'ombrelle sur la plage de Trouville
12.5 × 17.5 cm
Musée Eugène Boudin, Honfleur
page 104

PAUL CÉZANNE
1839–1906

Crossroad of the Rue Rémy, Auvers, c. 1873
Carrefour de la rue Rémy à Auvers
38 × 45.5 cm
Musée d'Orsay, Paris
© photo R.M.N.
page 77

Dr. Gachet's House at Auvers, c. 1873
La maison du docteur Gachet à Auvers
46 × 38 cm
Musée d'Orsay, Paris
© photo R.M.N.
page 79

The House of the Hanged Man, Auvers-sur-Oise, 1873
La maison du pendu, Auvers-sur-Oise
55 × 66 cm
Musée d'Orsay, Paris
© photo R.M.N.
page 81

Mill on the Couleuvre at Pontoise, c. 1881
73.5 × 91.5 cm
Nationalgalerie, Berlin
page 67

The Poplars, c. 1879–82
Les peupliers
65 × 81 cm
Musée d'Orsay, Paris

Village Road, Auvers, c. 1872–73
Route de village à Auvers
46 × 55.5 cm
Musée d'Orsay, Paris
© photo R.M.N.
page 78

JOHAN BARTHOLD JONGKIND
1819–1891

Sainte-Catherine, Honfleur, 1864
36.5 × 43.5 cm
Musée des Arts Décoratifs, Paris

ÉDOUARD MANET
1832–1883

Monet Painting in His Studio Boat, 1874
82.5 × 103 cm
Neue Pinakothek, Munich

CLAUDE MONET
1840–1926

Works by Claude Monet are reproduced with the permission of ARS N.Y./ SPADEM.

The Argenteuil Basin, c. 1872
Le bassin d'Argenteuil
60 × 80.5 cm
Musée d'Orsay, Paris
© photo R.M.N.
page 91

The Beach at Sainte-Adresse, 1867
75.2 × 101.6 cm
Metropolitan Museum of Art, New York; bequest of William Church Osborn
© 1989 by The Metropolitan Museum of Art
page 119

The Beach at Trouville, 1870
37.5 × 45.7 cm
National Gallery, London

Boats and Regatta at
Argenteuil, 1874
Barques et régates à Argenteuil
60 × 100 cm
Musée d'Orsay, Paris

The Bridge at Argenteuil, 1874
60 × 79.7 cm
National Gallery of Art,
Washington, D.C.; collection of
Mr. and Mrs. Paul Mellon
page 89

Camille Monet at the Beach
at Trouville, 1870
Camille Monet sur la plage à
Trouville
38 × 46 cm
Musée Marmottan, Paris

Étretat, 1883
66 × 81 cm
Musée d'Orsay, Paris

Flowering Garden, c. 1866
Jardin en fleurs
65 × 54 cm
Musée d'Orsay, Paris

Honfleur, the Belfry, Sainte-
Catherine, 1867
Honfleur, le clocher, Sainte-
Catherine
55 × 43 cm
Musée Eugène Boudin,
Honfleur
page 110

Hôtel des Roches Noires,
Trouville, 1870
81 × 58.3 cm
Musée d'Orsay, Paris
© photo R.M.N.
page 105

Impression, 1872
48 × 63 cm
Musée Marmottan, Paris
(Stolen 10/27/85)

Jeanne-Marguerite Lecadre in
the Garden, 1866
80 × 99 cm
The Hermitage, Leningrad

Pleasure Boats, c. 1873
Bateaux de plaisance
49 × 65 cm
Musée d'Orsay, Paris

The Railroad Bridge at
Argenteuil, 1874
54.3 × 73 cm
Philadelphia Museum of Art;
The John G. Johnson Collection
page 87

Red Boats II, 1875
55 × 65 cm
Fogg Art Museum, Harvard
University, Cambridge

Rouen Cathedral, the West
Portal and Saint-Romain
Tower, Full Sunlight,
Harmony in Blue and Gold,
1894
La cathédrale de Rouen, le
portail et la tour Saint-Romain,
plein soleil, harmonie bleue et or
107 × 73 cm
Musée d'Orsay, Paris
© photo R.M.N.
page 127

Rue de la Bavole, Honfleur,
c. 1864
55.9 × 61 cm
Museum of Fine Arts, Boston;
bequest of John T. Spaulding
© 1990 Museum of Fine Arts,
Boston
page 111

Sailboats on the Seine, 1874
54 × 65.4 cm
The Fine Arts Museums of San
Francisco; gift of Bruno and
Sadie Adriani
page 88

The Seine at Argenteuil, 1873
La Seine à Argenteuil
50.5 × 61 cm
Musée d'Orsay, Paris

The Seine at Argenteuil,
Autumn, 1873
56 × 75 cm
Courtauld Institute Galleries,
London (Courtauld Collection)
page 93

The Seine at Bougival, 1869
65.5 × 92.5 cm
The Currier Gallery of Art,
Manchester, New Hampshire;
Currier Funds, 1949.1
page 37

Train in Snow, 1875
Le train dans la neige
59 × 78 cm
Musée Marmottan, Paris
photo Studio Lourmell 77
page 96

CAMILLE PISSARRO
1830–1903

Côte des Boeufs, 1877
114 × 87 cm
Tate Gallery, London

The Ennery Road near
Pontoise, 1874
Route d'Ennery près de Pontoise
55 × 92 cm
Musée d'Orsay, Paris
© photo R.M.N.
page 63

Entrance to the Village of
Voisins, 1872
Entrée du village de Voisins
46 × 55 cm
Musée d'Orsay, Paris
© photo R.M.N.
page 21

The Great Bridge at Rouen,
1896
74.1 × 92.1 cm
The Carnegie Museum of Art,
Pittsburgh; Purchase, 1900
photo Richard Stoner
page 131

Harbor at Rouen, Saint-Sever,
1896
Le port de Rouen, Saint-Sever
65 × 92 cm
Musée d'Orsay, Paris

Hillside in the Hermitage,
Pontoise, 1873
Coteau de l'Hermitage, Pontoise
61 × 73 cm
Musée d'Orsay, Paris

Kitchen Garden and
Flowering Trees, Spring,
Pontoise, 1877
Potager et arbres en fleurs,
printemps, Pontoise
65.5 × 81 cm
Musée d'Orsay, Paris

Kitchen Garden at the
Hermitage, 1879
Jardin potager à l'Hermitage
55 × 65.5 cm
Musée d'Orsay, Paris

Moret, the Loing Canal, 1902
Moret, le canal du Loing
65 × 81.5 cm
Musée d'Orsay, Paris
© photo R.M.N.
page 51

Pontoise, 1872
40.5 × 54.5 cm
Musée d'Orsay, Paris

Pontoise, the Road to Gisors
in Winter, 1873
59.8 × 73.8 cm
Museum of Fine Arts, Boston;
bequest of John T. Spaulding
© 1990 Museum of Fine Arts,
Boston
page 65

Pontoise, Village of the
Hermitage, 1873
50.5 × 65.5 cm
Kunstmuseum, St. Gall

The Quays at Rouen, 1883
Courtauld Institute Galleries,
London (Courtauld Collection)
50 × 64 cm
page 129

Red Roofs, a Corner of the
Village in Winter, 1877
*Les toits rouges, coin de village,
effet d'hiver*
54.5 × 65.6 cm
Musée d'Orsay, Paris
© photo R.M.N
page 61

The Wheelbarrow, Orchard,
1881
La brouette, verger
54 × 65 cm
Musée d'Orsay, Paris
© photo R.M.N.
page 59

View from Louveciennes,
c. 1870
52 × 82 cm
Reproduced by courtesy of the
Trustees, The National Gallery,
London
page 16

Wash House at Bougival, 1872
Le lavoir, Bougival
46.5 × 56 cm
Musée d'Orsay, Paris

PIERRE-AUGUSTE RENOIR
1841–1919

A Road in Louveciennes,
c. 1870
38.1 × 46.4 cm
Metropolitan Museum of Art,
New York; bequest of Emma A.
Sheafer

Sailboats at Argenteuil, 1874
50 × 65 cm
Portland Art Museum, Oregon;
gift of Winslow B. Ayer

The Seine at Argenteuil,
c. 1873
La Seine à Argenteuil
46.5 × 65 cm
Musée d'Orsay, Paris
© photo R.M.N.
page 94

Versailles Road,
Louveciennes, 1895
*Route de Versailles à
Louveciennes*
32.6 × 41.5 cm
Musée des Beaux-Arts, Lille
page 23

ALFRED SISLEY
1839–1899

The Aqueduct at Marly, 1874
54.3 × 81.3 cm
The Toledo Museum of Art,
Toledo, Ohio; gift of Edward
Drummond Libbey
page 25

At the Bank of the Loing, n.d.
Au bord du Loing
37 × 40 cm
Musée des Beaux-Arts, Rouen

Avenue of Poplars near Moret,
1890
*Avenue des Peupliers près de
Moret*
65 × 81 cm
Musée des Beaux-Arts, Nice
page 47

Boat during the Flood, Port-
Marly, 1876
*Barque pendant l'inondation à
Port-Marly*
50.5 × 61 cm
Musée d'Orsay, Paris
© photo R.M.N.
page 33

Boats at the Bougival Lock,
1873
Bateaux à l'écluse de Bougival
46 × 65 cm
Musée d'Orsay, Paris
© photo R.M.N.
page 34

The Bridge of Moret, 1887
Le pont de Moret
63 × 51 cm
Collection Musée André
Malraux, Le Havre
page 49

The Church at Moret, 1893
L'Église de Moret
65 × 81 cm
Musée des Beaux-Arts, Rouen
© photo R.M.N.
page 53

Early Snow at Louveciennes,
c. 1870–71
54.8 × 73.8 cm
Museum of Fine Arts, Boston;
bequest of John T. Spaulding
© 1990 Museum of Fine Arts,
Boston
page 22

Farmyard at Saint-Mammès,
1884
Cour de ferme à Saint Mammès
73 × 93 cm
Musée d'Orsay, Paris
© photo R.M.N.
page 45

The Footbridge at Argenteuil,
1872
Passerelle d'Argenteuil
39 × 60 cm
Musée d'Orsay, Paris
© photo R.M.N.
page 90

The Loing Canal, 1892
Le canal du Loing
73 × 93 cm
Musée d'Orsay, Paris
© photo R.M.N.
page 48

Louveciennes, Hilltops at
Marly, c. 1873
Louveciennes, hauteurs de Marly
38 × 46.5 cm
Musée d'Orsay, Paris

Marketplace at Marly, 1876
50 × 65 cm
Städtische Kunsthalle,
Mannheim
page 31

The Road of the Machine at
Louveciennes, 1873
*Le chemin de la machine à
Louveciennes*
34.7 × 73 cm
Musée d'Orsay, Paris
© photo R.M.N.
page 19

The Seine at Bougival,
1872–73
La Seine à Bougival
46 × 65.3 cm
Musée d'Orsay, Paris
© photo R.M.N.
page 38

Small Square at Argenteuil
(Rue de la Chaussée), 1872
*Petite place à Argenteuil (rue de
la Chaussée)*
46 × 66 cm
Musée d'Orsay, Paris
© photo R M N.
page 95

Snow at Louveciennes, 1878
La neige à Louveciennes
61 × 50.5 cm
Musée d'Orsay, Paris
© photo R.M.N.
page 17

A Street in Louveciennes,
c. 1875
Une rue à Louveciennes
55.5 × 46.4 cm
Musée des Beaux-Arts, Nice
page 28

A Turn in the Road, 1873
54.5 × 64.7 cm
The Art Institute of Chicago,
Charles H. and Mary F. S.
Worcester Collection
page 27

Watering Place at Marly-
le-Roi, 1875
39.5 × 56.2 cm
The Art Institute of Chicago;
gift of Mrs. Clive Runnells
page 26

VINCENT VAN GOGH
1853–1890

The Church at Auvers-
sur-Oise, 1890
L'église d'Auvers-sur-Oise
94 × 74 cm
Musée d'Orsay, Paris
© photo R.M.N.
page 70

A Corner of Daubigny's
Garden, 1890
51 × 51 cm
Vincent van Gogh Foundation/
Rijksmuseum Vincent van
Gogh, Amsterdam

Crows over the Wheat Field,
1890
50.5 × 100.5 cm
Vincent van Gogh Foundation/
Rijksmuseum Vincent van
Gogh, Amsterdam
page 73

Daubigny's Garden, 1890
54 × 101 cm
Rudolf Staechelin Foundation,
on loan to Oeffentliche
Kunstsammlung, Basel

Dr. Gachet's Garden at
Auvers-sur-Oise, 1890
*Le jardin de docteur Gachet,
Auvers-sur-Oise*
73 × 52 cm
Musée d'Orsay, Paris

Landscape with the Château
of Auvers at Sunset, 1890
50 × 100 cm
Vincent van Gogh Foundation/
Rijksmuseum Vincent van
Gogh, Amsterdam
page 74

Mlle. Gachet in Her Garden at
Auvers-sur-Oise, 1890
*Mlle. Gachet dans son jardin,
Auvers-sur-Oise*
46 × 55 cm
Musée d'Orsay, Paris

A Group of Houses in a
Landscape, 1890
50 × 52 cm
Vincent van Gogh Foundation/
Rijksmuseum Vincent van
Gogh, Amsterdam

Village Street and Stairs with
Figures, 1890
49.8 × 70.1 cm
St. Louis Art Museum

Wheat Field under Clouded
Sky, 1890
50 × 100 cm
Vincent van Gogh Foundation/
Rijksmuseum Vincent van
Gogh, Amsterdam